Advanced Pinstripe Art
How-to Secrets from the Masters

Timothy Remus

Published by:
Wolfgang Publications Inc.
PO Box 223
Stillwater, MN 55082
www.wolfpub.com

Legals

First published in 2006 by Wolfgang Publications Inc.,
PO Box 223, Stillwater MN 55082

ISBN number: 1-929133-32-4

Printed and bound in China

Advanced Pinstripe Art

Acknowledgements

The book is nearly done, I'm left with typos to correct, and so many people to thank. Naturally the artists themselves are on the top of the list. Let me start the thanks with Steve Chaszeyka, who contributed a two-part pinstriping series, and also invited me to his Pinheads meeting so I could meet more stripers.

One of those artists is named East Coast Artie. Artie let me hang over his shoulder at Suck Bang Blow (I didn't make that up) in Myrtle Beach, and invited me to his shop, where I met Mark Peters.

Though Mark Peters may not be as well known as some of the other "names" in this book that has nothing to do with his level of talent. Mark's pinstripe work is as good as any, and his fine art work is off the scale.

Dan Kite is another striper I met in Myrtle Beach. While most stripers have a home shop, and only spend part of their time on the road, Dan pretty much travels from one event to another. Dan is pretty humble, calling himself, "just a striper and sign painter." Yet, there isn't much that Dan hasn't done or can't do, from stripes to cartoons, and yes, signs too.

Chris Fast, part owner of the Andrew Mack Brush Company, was in attendance at Steve's Pinheads meeting. Who's better prepared to help me with the Brushes side-bar seen in the middle of the book?

I met Tex McDorman during a photo shoot at Brian Klock's custom bike building facility. Tex's talents go beyond pinstriping to custom painting in general. If that weren't enough, Tex possesses a ton of charm - unflappable might be the right word to describe Tex. At Brian's shop, Tex had his own little side show going on, striping everyone's cell phone and camera while he cracked jokes and kept the whole place jumpin'.

A little quieter, but no less talented, is Keith Hanson, who does some high profile work for bike-builder Dave Perewitz. Keith is another one who's comfortable with a pinstripe brush, airbrush, or spray gun.

Robert Pradke is likewise a multi-talent, as happy chopping the top on some old leadsled as he is laying out a very unique pinstripe design on the tank of a custom motorcycle. Many of the wild paint jobs on the late Indian Larry's bikes are the work of Mr. Pradke.

Nick Pastura can and does paint anything and everything. From the backdrop used by the band U2, to helmets for a variety of NASCAR drivers. In between he builds and paints bitchin' custom motorcycles and collects fine cigars. Whatever he puts on his cereal in the morning, I want some. Nick gets a lot of work done.

Lenni Schwartz, who works under the name Krazy Kolors, might be called the best-kept secret in Minneapolis and St. Paul. Locally famous, Lenni's best-known work turns up on bikes built by Donnie Smith, though he also does a wealth of work for smaller shops and individuals.

Another local legend, Brian Truesdell, splits his time between pinstripe jobs, and lettering on trucks and commercial vehicles. He's one of those guys who make it look very easy, just grab the brush and follow that line where the edge of the flame lick meets the black. Now change colors in the middle of a line. Nothin' to it – when you've been doing it for thirty years.

I called Jon Kosmoki Mr. Paint. Because he is. And though he's not a working pinstriper, he's the person who developed the paint that a huge group of working pinstripers use every day. Jon is also a true do-it-yourself guy, so it's not surprising that he figured out years ago how to do his own pinstripes.

As a group, these pinstripers are very talented, hardworking, humble and mostly self-taught. They're also very generous with their time and willing to share with the rest of us some of the tricks they've learned over the years. And for that I'm very grateful.

The work of producing a book is just that, work. Which would never be finished without the layout work by Jacki Mitchell, the office management of Krista Leary and the proof reading by my lovely and talented wife, Mary Lanz.

Introduction

The Pinstripe book you hold in your hand is another in our "advanced art" series. The main idea behind all the books in this series is to let the artists tell the story, and keep the author out of the middle. Each artist gets one chapter to explain and show people how they do what they do, and what it is that separates their work from all the rest. The photo intensive format makes for a great how-to book by taking the reader right into the shop of the artist. The wealth of photos also creates a format with appeal to anyone interested in that particular art form. This is an opportunity to admire tattoo, airbrush and pinstripe work done by some of this country's best artists.

Whether it's an airbrush, pinstripe or tattoo artist, each has a story to tell, a way of using the brush or combining colors to achieve a certain look and visual impact. This particular book takes the concept one step farther. In most cases the artists wrote their own captions. These artist-written captions add a great deal of integrity and interest to the book. Now you really know exactly why Artie uses a number one Mack brush and how The Wizard learned to do the scrolling designs he does so well.

Because it's labeled an Advanced book, we've deleted the Brushing 101 part of the how-to sequence, (though we did a Brush side-bar with Chris from Andrew Mack Brush Company). Instead, we bring you the work of eleven very experienced artists. If you want to know how to do something, ask the person who does it all day long. And that's exactly what we've done. Think of it as a video done with still photography. All the steps are here, from blank panel to the finished art.

The book includes eleven projects, from outlining flames to striping an old Ford Dashboard. Some of the artists are well know and others are still-to-be-discovered. Yet, each is skilled and has something to teach us about the unique way they paint and use pin-stripes.

Read, admire, enjoy and learn.

Chapter One

East Coast Artie

Keep it Simple

East coast Artie is a man who definitely knows when to say when. Though he will do whatever the customer wants, his own designs fall into the less-is-more category.

The design seen here uses what Artie calls, "a cool trick I learned from Jim Norris that I believe started with Russ Mowry. This is a mechanical drawing compass with a tip you would use with India Ink. You can use it to make neat circles and half circles. With the tip rounded off a little bit it

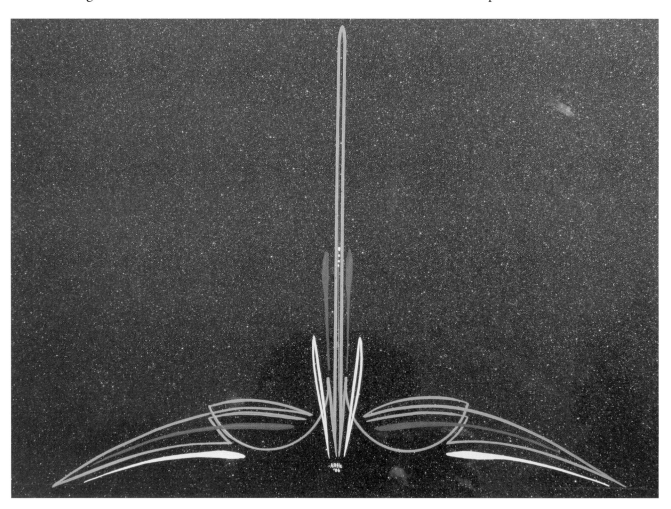

This is a style of striping I like to use on more "high tech" vehicles. The double line in the center serves as a focal point and the half circles give it a "precision" look. In this case, less is more.

All captions by East Coast Artie.

holds paint really well." The brush Artie used is an Xcaliber, 4-zero. "This is what I generally use," explains Artie, "because I can pull a fine line. If I'm doing really long lines I use the Mack, Mach-One. For letter brushes I use Heinz-Scharff, usually sold as a Scharff, and I use Mack lettering brushes too. One other type of brush that I use is a Mack called the 'virus' that I like because I can sign my name with them. Dave-The-Letterman came up with this brush, it has a good tip and I can sign my name really small."

The finished panel is a combination of spare lines, half-circles and a few arched lines. The work is done with the old standby, One-Shot lettering enamel.

1. I start by laying two straight fine lines down the middle. Notice the stabilo pencil mark down the center. I use teal as my base color.

4. You have to get the paint/flow combination worked out yourself. Every tip is different. If you have tested and have the flow right, you can CARE-FULLY set your compass on the surface and pull nice clean arched and half-circles.

2. I then peak the lines at the top to join them.

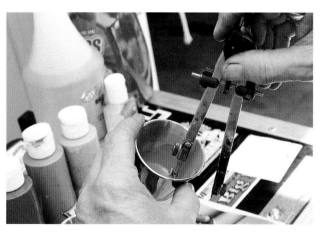

3. To use the compass, thin the paint with lacquer thinner to speed the flow with a quick set. You might want to slightly round the tip on the compass, so as not to scratch somebody's $60,000 toy.

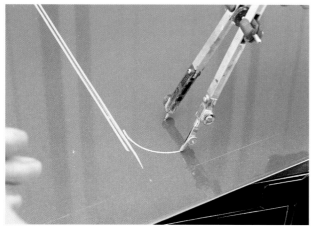

With a smooth twist, rotate the compass just fast enough for the paint to flow off the tip.

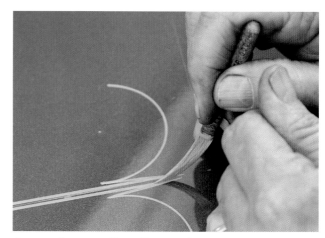

I try to keep my lines fine, and consistent.

Careful is the key word. It's easy to slip or drag the compass too hard. Practice, practice, practice.

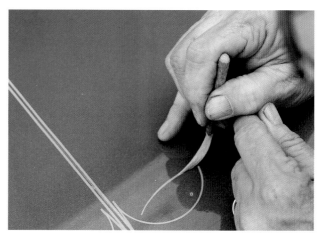

Now I pull a line back, to bring the circle back into the design.

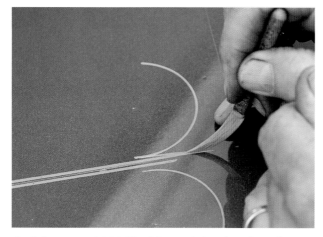

I pick up my 0000 Xcaliber striping brush and connect the circles to my center lines.

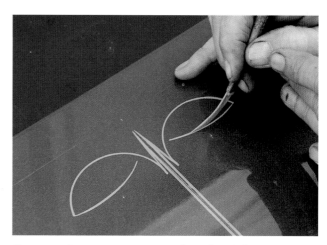

I repeat the same process on the other side.

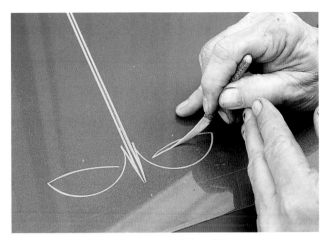

Now I pull a line back out of the design...

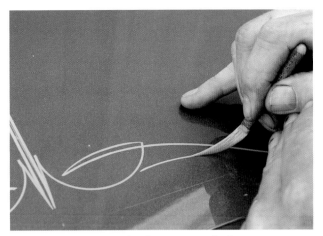

The next line turns back in, towards the center...

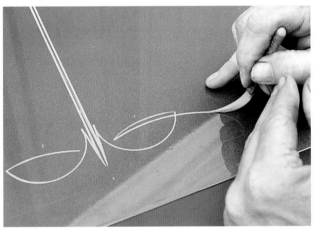

...away from the center...

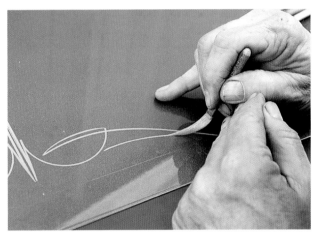

...but, notice how I work from the design out, to get a sharp point...

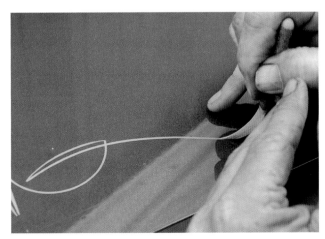

...all the way over to the side, where it will connect with another line later.

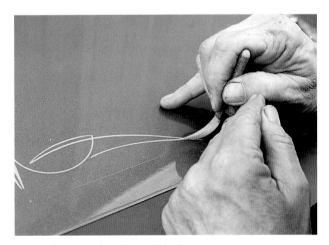

...on the outside edge of the design.

9

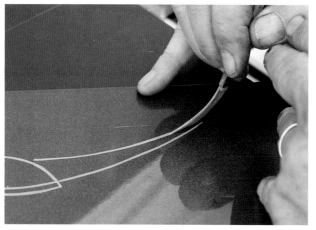

Here's a shot connecting the outside lines.

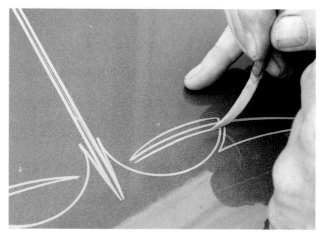

Here I make that last connection and it's time to clean out the brush.

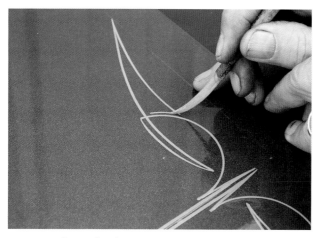

Notice I keep the design "open" as I plan to add additional colors without making the design too busy.

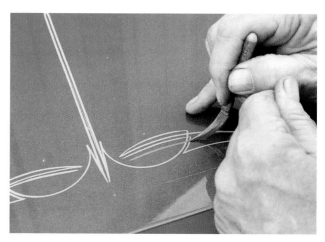

I start adding magenta to the design.

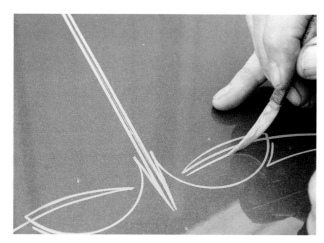

I add a couple more lines to connect the open ends, and the design will be ready for the next color.

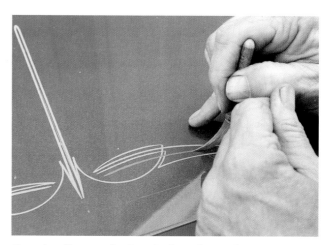

I can't tell you why I pick the colors I do...it just depends on the color that I am working on, my mood, and when necessary, the customer's opinion.

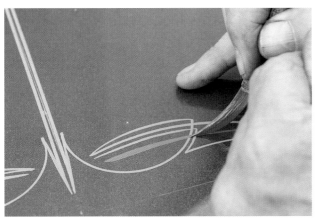

These teardrop lines add a lot of "fill" to a design while still keeping it simple. For these teardrop-type shapes I lay my brush into the surface and lift up as I pull the line away. Easy.

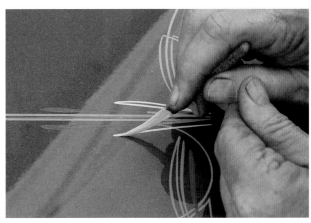

Now I've switched to One-Shot aqua and lay down some more lines.

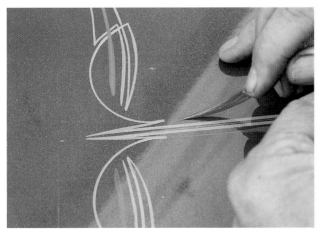

You can also start at the point and lean your brush into the line as you go, for the same effect. This makes it easier to curve them.

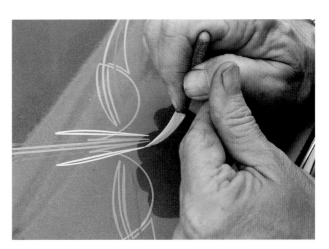

Notice these shapes are similar to the teardrops, but open. This keeps the theme consistent throughout the design.

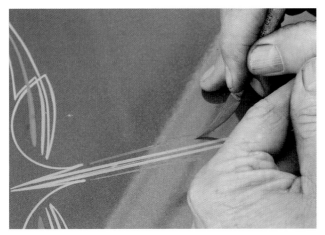

A couple more next to the center line, just 'cause I like the way it looks, time to clean the brush again.

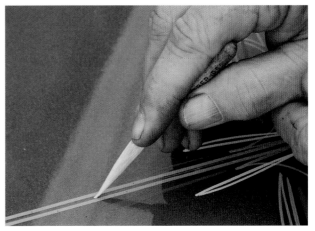

Now I flip over my brush to lay some dots down the center.

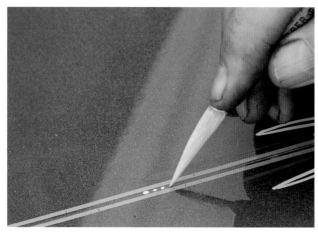

I make the size of the dots decrease as they repeat. Pulling your brush a bit makes ovals instead of round dots.

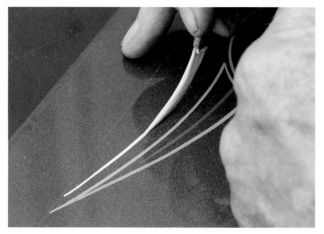

This line will lead up to a teardrop.

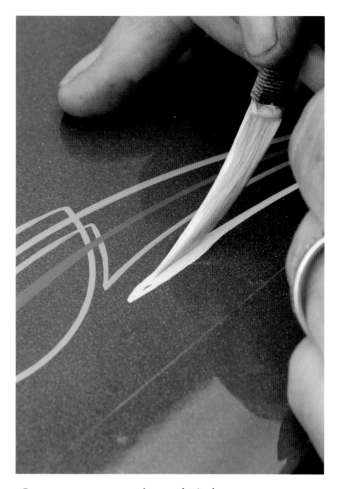

One or two more strokes and it's done....

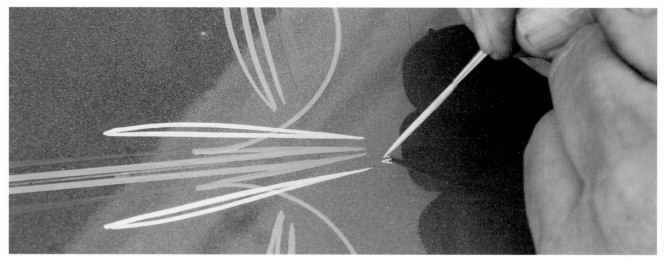

...well, almost done, I've got to sign it.

Q&A: East Coast Artie

Artie, How did you get started in pin-striping?

I started in Totowa, New Jersey when I was 13 years old. I was working in a body shop after school, Tony's Custom Auto Body. One day I was lettering a '58 Pontiac in the school parking lot, I used an Old English lettering style, my art teacher showed me some other lettering styles, script styles, and really got me going in the right direction. He, and my mechanical drawing teacher, taught me things like perspective. Harry Bradly, the designer, was in a local car club and would come to Tony's. Harry taught me how to draw chrome. All these people were feeding me information, I was very fortunate.

I did striping while I was in the service, later my wife and I had a shop in Colorado for nineteen years. We moved the shop to Pennsylvania for five years and now we're in Myrtle Beach. Currently my work is eighty percent pinstriping and the rest is signs.

What makes a good pinstriper?

You need to be an abstract artist, you have to be able to think two inches ahead of your hand. I like to see people do work that's really different, pinstriping should be very individualistic. To see someone try to be Von Dutch, I think they are missing the point. First you need to get the basics down, then I like to see people stretch it. I try to do different work all the time. The stripers I like have good line quality, good tightness and consistency.

You first have to know how to handle the brush, not only that, you have to get real comfortable with the brush. It's a hard combination (I relate it to steel guitar music, those notes are long and they resonate).

What do you like for brushes?

Xcaliber 0000 is what I generally use, because I can pull a fine line. If I'm doing really long lines I use the Mach-One. For lettering brushes I use Heinz-Scharff, usually sold as a Scharff, and I use Mack lettering brushes too. I also use another Mack,

"the Virus." Dave-The-Letterman came up with that brush, it has a good tip and I can sign my name really small.

How do you store your brushes?

In Xcaliber brush preservative, which has a lot to do with why my brushes last as long as they do.

Where do you get ideas and inspiration?

In the early days it was Kenny the Mad striper and Larry Watson from California. Today there's Joe Buck, and Mr. J. and so many more. It's like a mutual admiration society, everyone is very supportive. Neal Millard in England, he's very, very good. Hanging out with him has changed my striping.

Any final words of wisdom?

I recommend that people have music on when they work. For me it's almost a Zen thing, I get into that mind set, I can work next to a dyno booth and it doesn't bother me. The most comfortable time in my life is when I have a brush in my hand. I do fine art work too and my wife just lets me go. My wife, Linda, has given me the opportunity to be as good as I am. I'm 61 and I'm enjoying it more than at any other time in my life. I consider myself lucky, I'm grateful that I can still do this, people who have talent and are able to use it in their life, that's great.

Artie's Tricks

A pounce pattern is a handy way to "grid" the surface for a design. A pounce wheel, or dressmaker's wheel, punches holes in the pattern paper that chalk can go through to mark the surface.

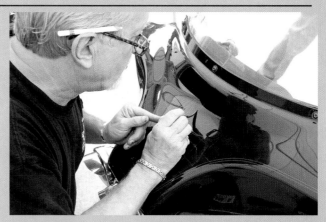

I keep building the design until it looks right to me. Sometimes when I start off, I am completely lost, but it always seems to come together.

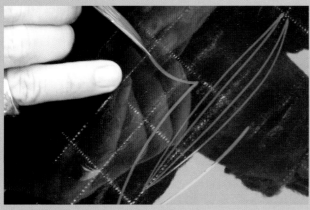

This makes it a lot easier to get "side to side" uniformity. It can be blown off with a can of air when you're done. That way, you don't have to touch the wet paint or send your customer off with lines all over his bike.

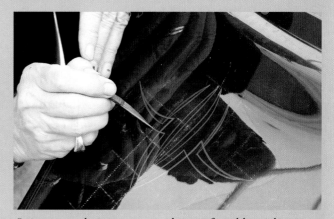

It is extremely important to be comfortable with your striping before you venture out to do it in public. I like the pressure of striping at motorcycle events, I feel it tightens up my work.

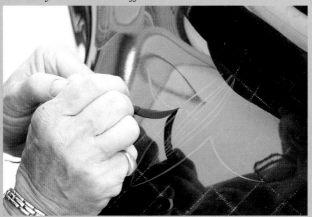

Here again, I can't explain where my designs come from, they just happen. I vary my style as often as I can to keep it from getting boring. I'm always looking for a different way to do it.

Once you learn to master the brush, practice developing your own style. It will make it easier and more enjoyable for you. There are no rules in this business.

Artie's Tricks

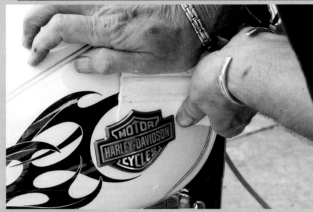

Here's a Harley tank with the factory tribal decal and metal emblem which I am removing by insetting a squeegee between it and the tank. Then you get to remove the adhesive, which is always "fun".

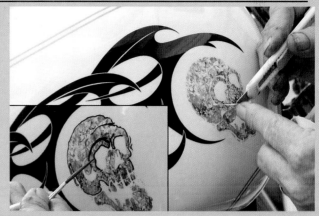

After removing the stencil, I detail the skull with a Mack Virus Brush.

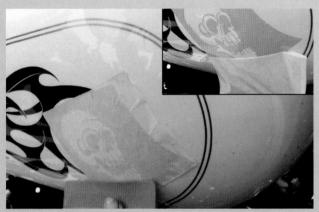

I now apply a pre-cut vinyl mask of a skull design to the tank.

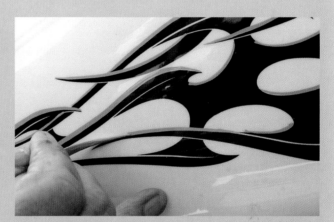

Now I add a light pinstripe line to the top edges of the tribal design.

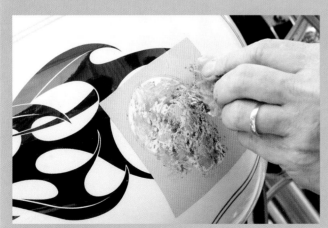

Instead of a brush, I use a sponge to color the skull. I add white and black sponging to get highlights, shadows, and texture. It's quick and easy.

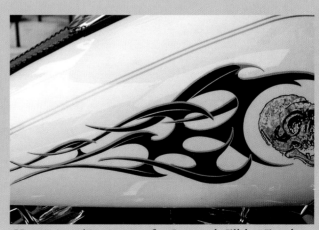

Here it is…45 minutes after I started. I'll bet I've done the highlight trick at least once a day during the Myrtle Beach Harley Rally.

Chapter Two
Dan Kite

Second Generation Sign Painter

Dan Kite must have a little gypsy blood in his veins, because he spends much of each year on the road, moving from one event to another. He finds it more rewarding, in all senses of the word, than running a sign and pinstripe shop back home. One of the many events that Dan attends is Myrtle Beach Bike Week, where he had the misfortune of running into Wolfgang Publications. "I'm just a pinstriper and sign painter," is the way that Dan describes his work.

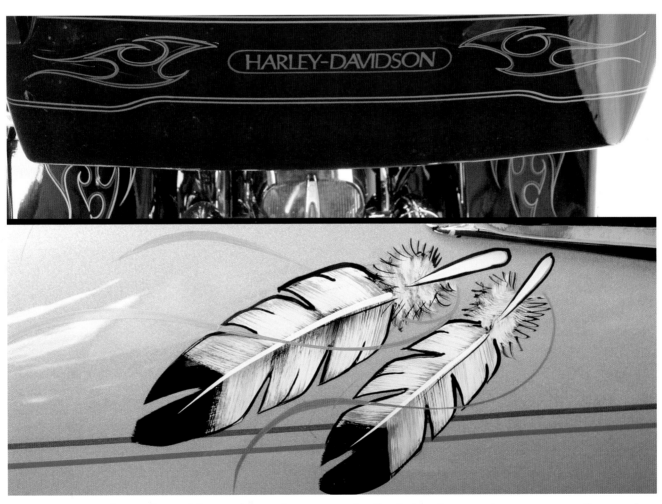

Pinstriping isn't always about elaborate designs done on panels. Good pinstripers need to create appealing art that works with an existing design or color, all while answering questions from other customers and dealing with a sometimes challenging working environment. *Captions by Dan Kite*

Yet, after more than thirty years of "just pinstriping and signs" Dan is very good at what he does.

The only formal art training Dan ever received occurred during high school art class. What he learned from his sign-painter father, doesn't count as formal, but probably has a lot to do with the direction Dan took in life. Though Dan did more sign work at one time, he made a conscious decision to concentrate on pinstriping. "I used to do more sign painting," explains Dan. "But once the computers came in I moved to more pinstriping work because I like doing the hand work."

The two projects seen here include a pinstriping job and a set of feathers, done on different bikes. These are both good examples of the kind of work pinstripers do on a day-to-day basis. These aren't complete paint jobs, and they aren't designs done on panels. Owners of bikes (and cars) who attend the big shows are looking for something that will set their bikes apart from all the rest. Something that will add some visual pizzazz without draining the bank account. As Dan says, "I have to pick a color and design that works with the colors that are already on the bike."

For the Bagger, Dan chose silver and blue. The silver matches the stripes already on the bike, the blue was the customer's choice and it works. We've not shown the entire project, but only the work on the tour pak. The blue used in parallel to the silver on the abstract part of the design, is the same color used for the Harley-Davidson script added to the sides of the Tour Pak.

The feathers are one of those jobs that looks simple when done by a professional, but you should probably think twice before trying this at home. "They look bad until the end," warns Dan. And he's right. At the very end all the little steps, all the colors, and all the blends suddenly come together to become two simple and realistic feathers.

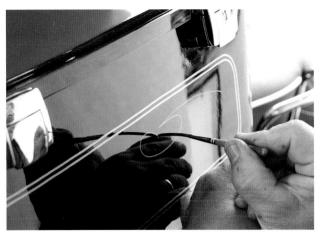

The job here is to embellish the Bagger.

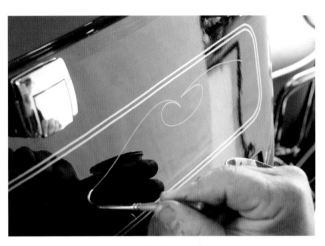

Taking the color from the factory pinstripe, Dan starts with a tribal design.

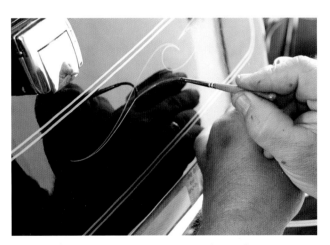

While the pinstripes are very straight and rectangular, this new design rolls and scrolls across the tour pak.

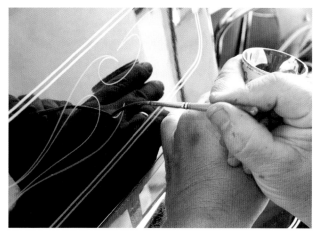

"I've done this kind of thing many times, I just start striping, without any preliminary sketches."

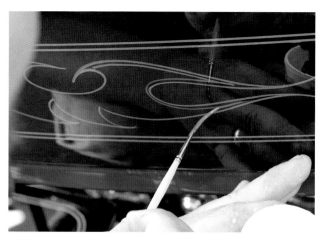

The customer suggested a blue hue...

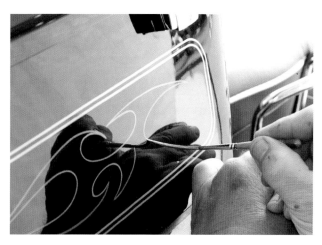

...Dan continues adding to the silver outline with a Kafka #3 brush.

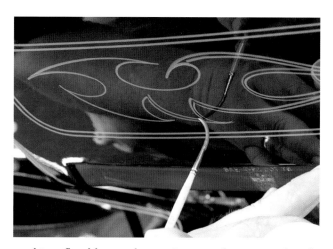

...this reflex blue makes a nice complement to the silver...

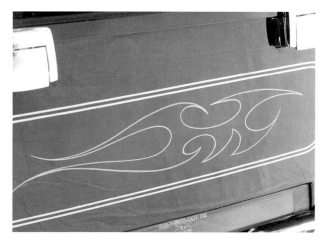

The finished design, complete with the points and axe shapes. All we need now is a little more color.

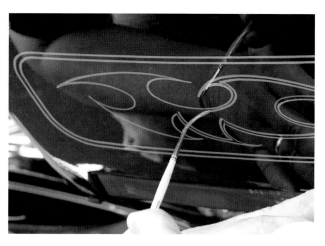

...bright without being too loud.

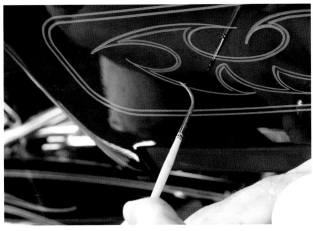

...Dan carefully runs the blue pinstripes parallel to the silver.

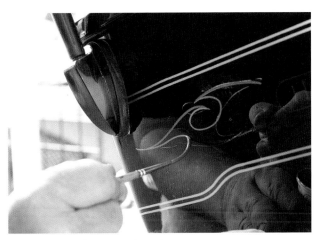

...of the Harley-Davidson logo.

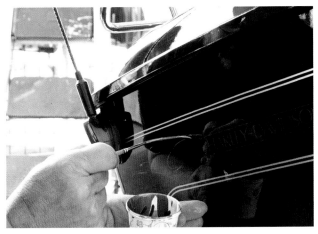

Now, moving to the back of the tour pak...

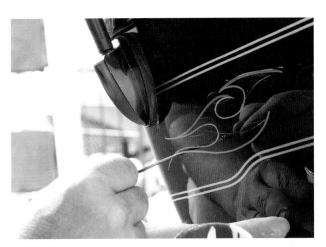

After finishing up the tribal design...

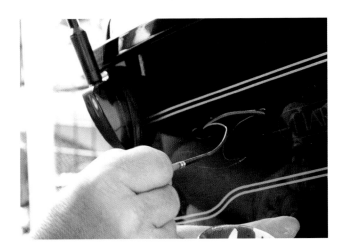

...Dan adds a smaller version of the design on either side...

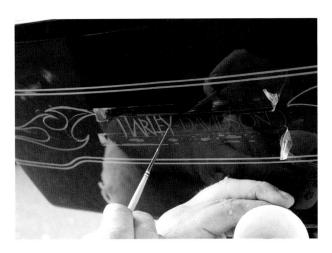

...Dan paints over the factory logo with the blue seen earlier.

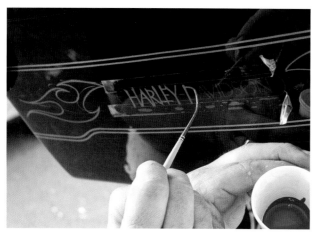

Using a lettering brush, Dan puts enough blue on each letter to totally cover the factory color.

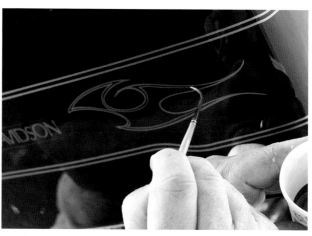

"I do use a true palette when I'm doing long pinstripes, but otherwise I prefer the Dixie cups."

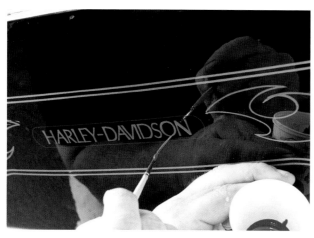

"I always work from a dixie cup, I just dip the brush and kind of palette it on the side of the cup. I think it's faster."

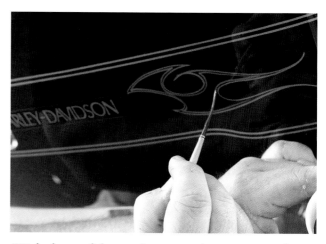

With the confidence of a seasoned pro, Dan makes the addition of a second line look easy.

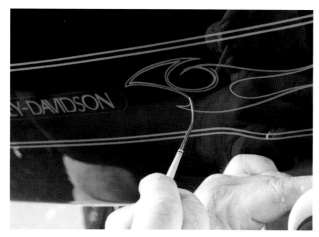

The blue Harley-Davidson lettering helps tie the whole thing together.

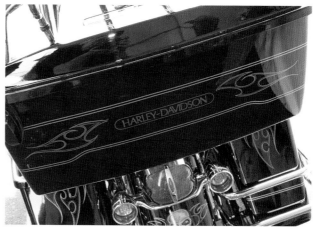

Most bikers who come to Dan's booth at an event are looking for something that will "make their bike cool" and separate it from all the others.

Q&A: Dan Kite

How did you end up a pinstriper?

My Dad was in the sign business. He had a shop near Albana, Illinois most of his life, He was an exceptional talent, I grew up in the shop and learned from him. Back in those days we did a lot of pinstripes on cars, in addition to the signs.

I bought the shop from Dad in the 1980s and had it for 15 years. I got disenchanted when the computers came in though. I like working by hand. Now I spend most of my time on the road, working at motorcycle events.

What's the hardest part of being on the road so much and working out of a booth?

One of the main things is the working conditions. You can't control the weather, it might be windy, raining or cold, and you still have to get the work done. Even though we have a tent, it's not the same as being inside where it's temperature controlled.

There is pressure too. People are standing around and you have to work quickly. Partly just to make a living and partly so those people don't get impatient and leave. In order to make any money you have to work fast, even in difficult conditions, and always keep the customers happy.

Where do you get your ideas?

From fellow stripers, people like Mike Lavelle and The Wizard. Sometimes you see work by someone you've never heard of, and it's great. Signage too, good signs can be inspiring.

How do you decide on your color combinations?

Mostly it depends on what color the bike maker put on there. They always have a color for the striping or the logo or something, or the color of the bike itself. I stay in that area of color and try to make everything work together, so it looks like it should be on there. People want stripes and art on their bikes the way they want another accessory, it makes the bike look cool and different from when they bought it. The extra paint helps make it their own.

What do you like for brushes?

I used to use Mack, now I use Kafka brushes, developed by Steve Kafka. I fell in love with his brushes, for all my pinstriping I use a Kafka number three. For lettering I pretty much use whatever I find at Michael's.

How about your choice for paint?

I always use One-Shot, I was just talking to Tramp, the representative for One-Shot, he was telling me they have some new colors coming out. I don't catalyze it, unless the customer tells me they're going to clear over the pinstripes, then I add hardener.

Any advice for beginning stripers or someone who is trying to get better?

Do a lot of pinstriping. Nothing improves you like repetition. And go to some of those seminars and pinheads meets, they're very good and you can learn a great deal.

Dan says he got the idea for these feathers from Mike Lavalle. The first step is a sketch, "so I know the size and angle of the feathers."

Next comes a little embellishment on the shaft.

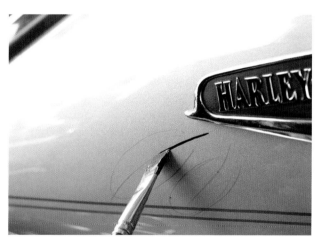

After sketching in the feather outlines, Dan starts with the spine of the feather...

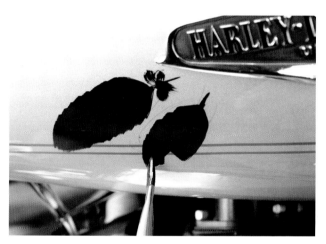

That same procedure is followed for the other feather.

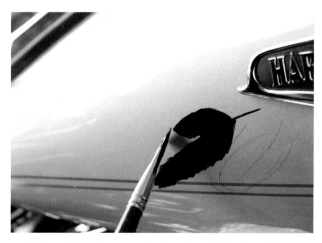

...followed by the basic body of each feather. "I always start in black, unless it's a black bike and then I start in brown."

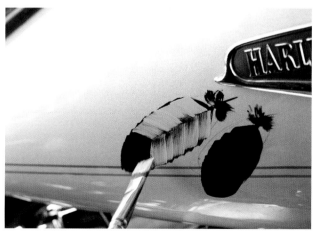

Now Dan goes over both with a light tan color, allowing the colors to mix a little. The black is tacked up, but not fully dry.

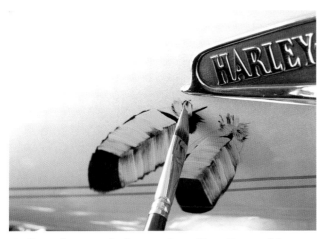

Still working with the tan One-Shot, Dan adds details to the shaft.

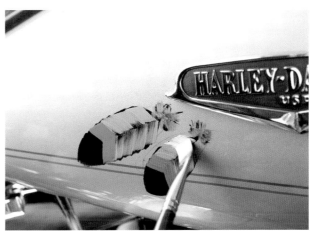

The last color is white...

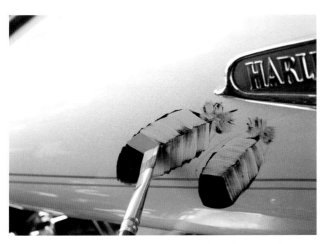

Blue comes next. "Here I pick a color that works with a stripe color, or the bike's color."

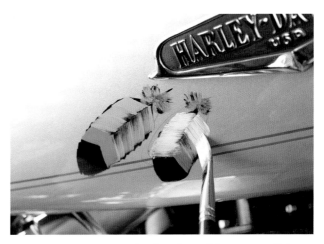

...again, Dan uses a dry brush and lets some of the underlying color show through...

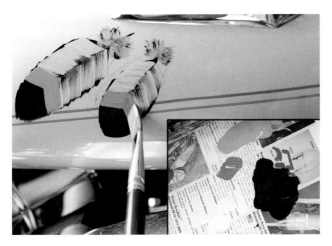

The blue is only used near the end of the feathers.

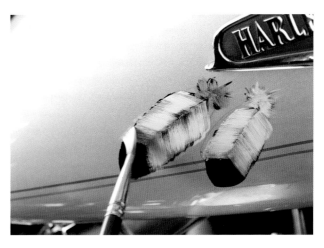

...even the blue at the tips.

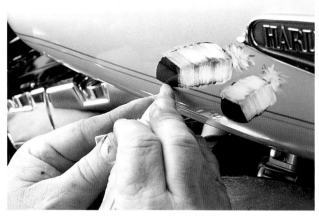

1. Dan wraps a brush handle in heavy paper towel, dips the towel in thinner...

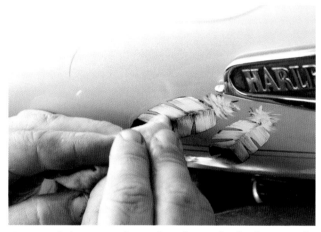

2. ...and then uses the end to shape the feathers, and to create the breaks seen here.

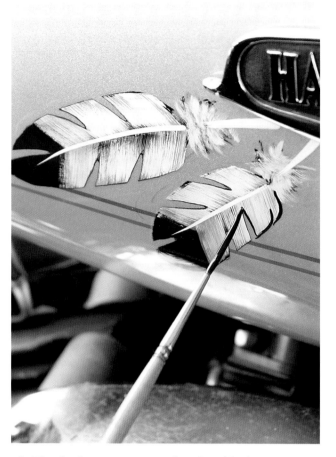

4. The feathers are now outlined in black.

3. Next, white is used to help define the shaft.

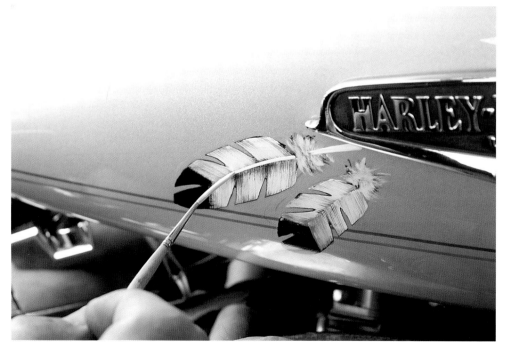

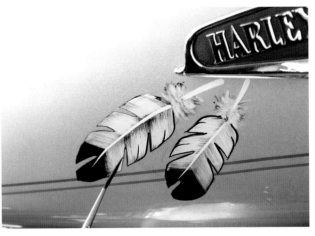

1. The outlining is done in a series of steps.

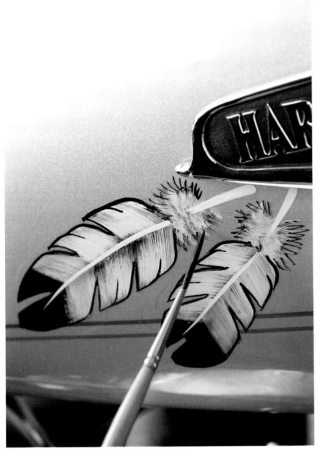

3. The small details mean a lot. "People really like what we do with these little tufts of feather on the base of the shaft."

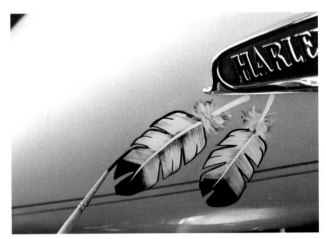

2. Dan works quickly along the edge until he gets to the black tip.

4. "The last thing I do is add pinstripes that run through the whole thing, they add motion and make it seem like the feathers are blowing in the breeze."

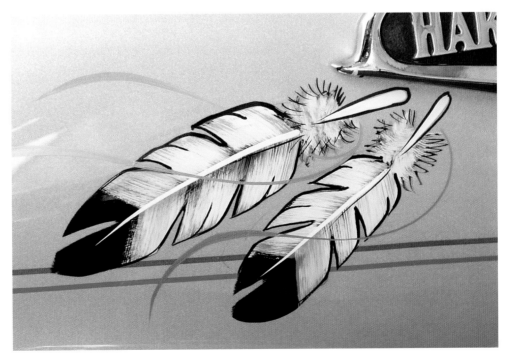

Chapter Three

Keith Hanson

Pinstripes done with Gold leaf

The work seen here is from Keith Hanson, and the project itself is much more than just a pinstripe design. This panel is being created for another artist, Vince Goodeve. The project includes everything: sponge painting, gold and silver leaf, and some very fine-line pinstripes. Part of the panel is already done. We come in just as Keith starts by adding a centerline, then

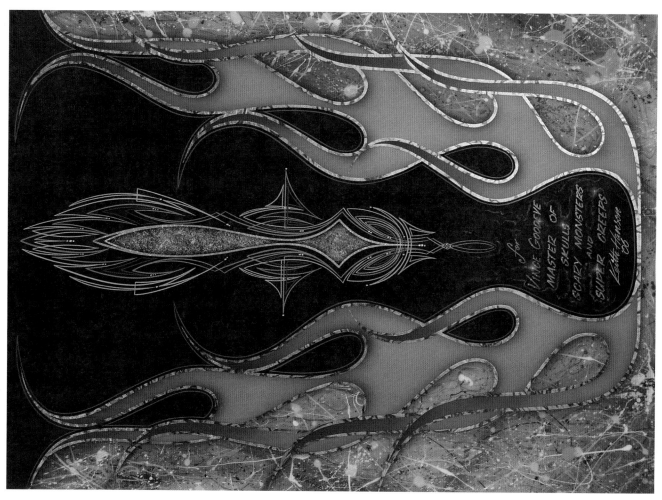

Even with all the chaos, the panel has a clean look and fine detail that is achieved with the pinstriping.

All captions by Keith Hanson

the outline for the central part of the design. Next, the central part of the design is masked off before Keith starts in on the area with a sponge and a palette full of House of Kolor striping urethanes.

The small sponge and Keith's random application of paint leaves the area with what he calls, "a marblized effect. You could also use One-Shot for this." Keith goes on to explain, "The H of K urethane is easier because I intend to clear this panel."

"I start with the darker colors and work toward the lighter colors. With each application (or color change) you put a little less on the panel. The last colors to be applied with the sponge are a series of neons, followed by limited highlights in white."

The next step in the process is the use of a Richpen airbrush to apply a light border of candy red. Now it's time to pull the tape and move on to the next stage in the creation of this very elaborate panel.

PINSTRIPING BEGINS

Keith often uses gold leaf for the pinstripes. It's an interesting process and a way for Keith to separate not only the flames from the rest of the panel, but his work from so many others. What looks like pinstriping paint being applied to the edges of the flames, is actually sizing (the adhesive used with gold leaf) mixed with gold paint.

Looking extremely fragile, the gold leaf sheets are laid down after the sizing has set up for the requisite period of time. Keith pads the leaf down with the heel of his hand before gently pulling off big sections that are not adhered, and repositioning them on another section of size. If it all sounds a little confusing, just flip ahead to the photo sequence, which should clear everything up.

Following the application of the gold leaf, Keith starts in with a series of extremely fine lines, laid down outside the sponge-painted design area in the center of the panel.

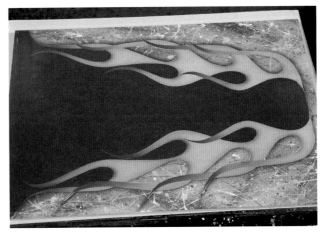

At this point the graphics are complete and ready for pinstriping and close up details.

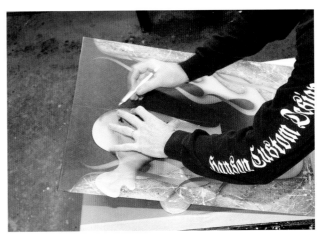

I begin the layout by marking the center with a white Stabilo pencil. Using a template I can begin the design layout.

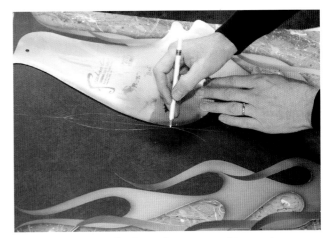

Now I continue the basic layout, working to insure symmetry.

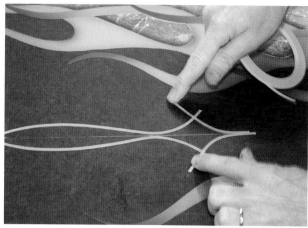

Using 3M green fine line, I tape off the body of area to be sponge painted.

Now I continue the process with the next color. This is House of Kolor violet (U 29), tinted with H of K white to give different tones of the same color.

To protect the background I use 1.5 inch masking tape. A sharp #11 X-acto blade is the perfect tool, be careful not to cut through the green fine-line tape.

Next, H of K aqua (U 31). Here you can see that the marbleizing effect is beginning to take place.

With a damp sponge I begin, using the darker colors first. This is House of Kolor blue green striping urethane (U 16).

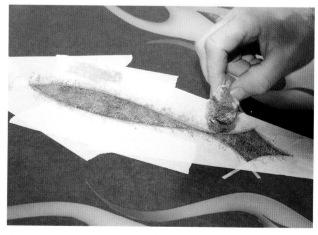

It's time to start using lighter colors, which will create the sense of a background coming from underneath.

The fine-line design starts in violet and progresses through a series of colors, including, aqua, peach and magenta. Not to mention more blue green pinstripes laid down around the flame licks, just outside the gold leaf. "You have to be careful with a symmetrical design," warns Keith, "or you can get off track easily. When you're using lots of colors like I am, you have to think about the next step otherwise you find yourself cramming in the next color."

To avoid any cramming, Keith is very careful about the location of each line, and each color, often checking the location on one side before duplicating that line on the other side. The final touches are the neon highlights, and then the silver leaf used to outline the center of the design.

To hear the creation of this panel described in words, you would think the design far too busy. Yet, when viewed, the panel is simply a stunning piece of art made up of many different elements, each one contributing to the whole.

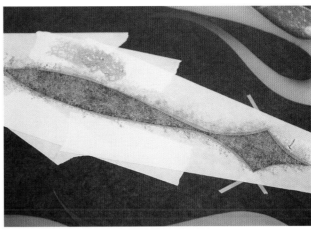

I like to apply the colors in a random fashion, being careful not to overdo it.

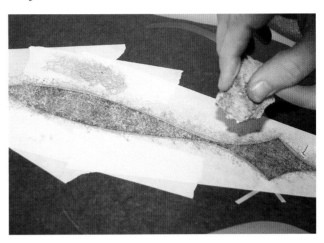

Now H of K magenta (U 14) is used along with lighter colors to separate the foreground even more.

Remember to use less of each color as you go along so you don't bury all the work you've already done.

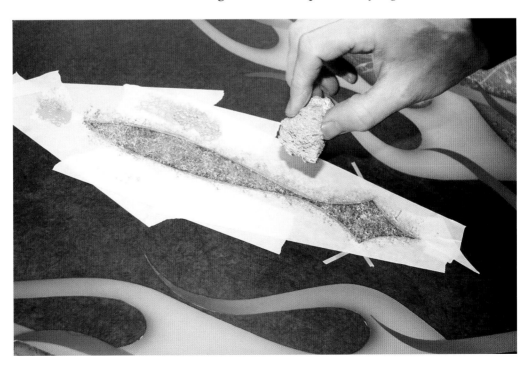

At this point I want to use some neon colors to brighten up the foreground.

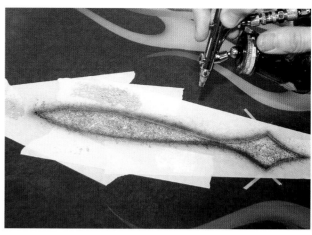

A little bit of shading with PPG candy red along the edges adds more dimension.

House of Kolor neon pink, green and chartreuse applied in small doses, does the trick.

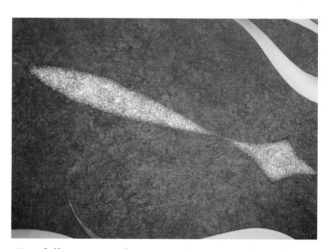

Carefully un-tape the area and you're ready to begin striping.

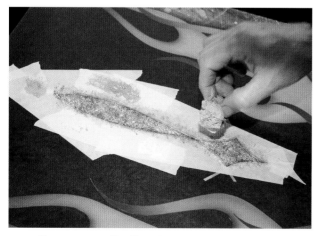

Finally, I top it all off with very small dabs of white to create some highlights.

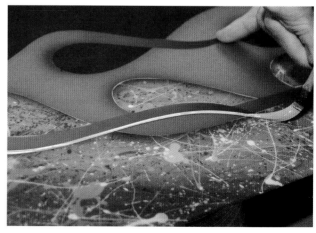

The flames will get a variegated gold leaf outline. What looks like pinstriping paint is actually quick sizing mixed with One-Shot imitation gold.

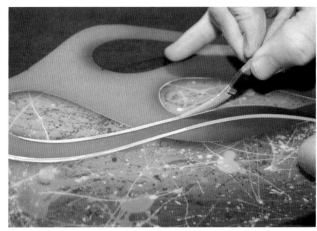

All the "striping" is done with an Xcaliber striping brush, this is a number 0. The short hairs help the brush hold its shape.

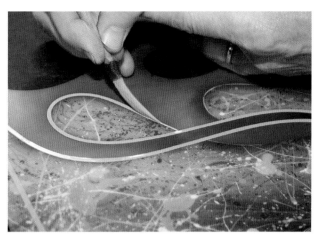

At intersections I start at the finished striping and pull away, so that I don't overlap stripes. And you can see better at the tip of the brush than at the heel.

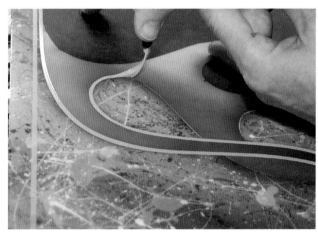

I like to support my striping hand with the other hand, and "roll" the brush through the curves.

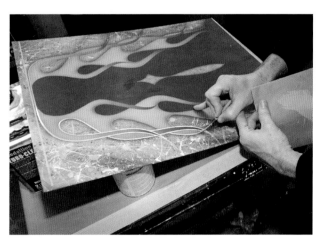

I use the striping as an opportunity to elongate or shorten the flame tips...

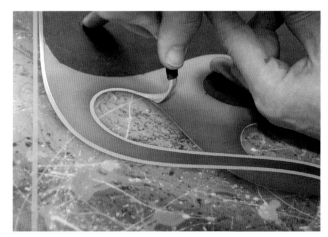

I like to stand the brush up on the tip as I roll through the curve.

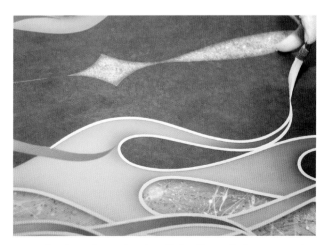

...notice here how the tip of the flame is longer and the curve at the end is exaggerated.

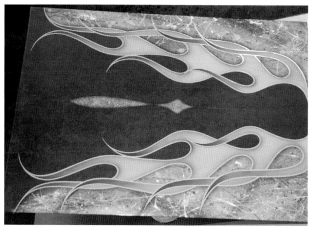

Now we wait for the adhesive to tack-up. The sizing is ready when you can touch it with the back of your finger and it feels sticky, but no paint comes off.

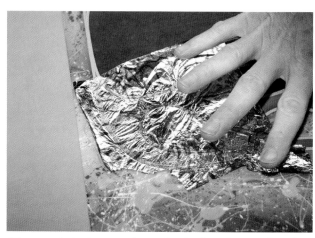

Try to minimize touching the leaf with your hand, and make sure the leaf is in place before pressing it down.

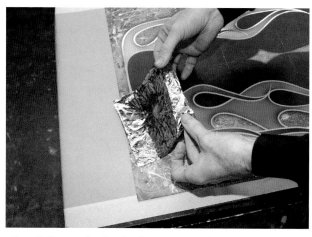

Carefully apply the leaf, try not to have it fold over or bunch up. Leaf comes in various colors and styles, this is red variegated leaf.

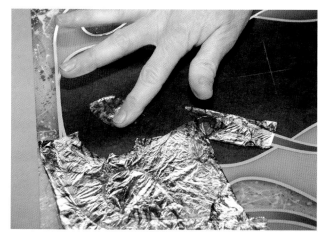

I carefully remove excess leaf with my finger tips and only re-use larger pieces of excess leaf on other areas.

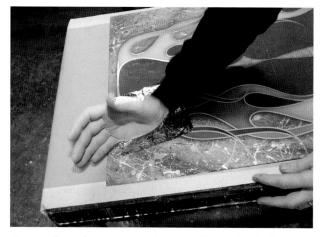

Lay it flat, then press it down with the heel of your hand. I try to keep my hands dry and free of any oils.

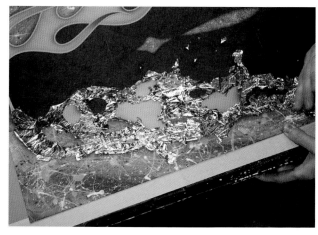

It's a constant process of pushing the leaf down, then tearing off big chunks which are applied to other areas of size, then pushing the new sections of leaf down.

Q&A Keith Hanson

Keith, tell us a little bit about how you came to be a pinstriper?

When I was about 20 years old, and just married my wife Faith, I worked as a milkman. At the time we worked four days a week at the dairy and I would stripe cars on my day off. A stripe job back then was 25 bucks, 35 for two colors. One day I did a Falcon for the foreman at the dairy, he came out when I was done, took a long look at what I'd done and said, "what are you doing delivering milk for a living?" His comment really helped me decide to go out on my own.

When I did go out on my own I came across a company that did detail work at dealerships. Next I started working with John Hartnett, we did a lot of race cars. Eventually I made the transition from race-cars to motorcycles. About that same time I met Dave Perewitz, and now I do a lot of work for Dave.

Talk about your creative process. And where you get your ideas?

I try to get ideas and influence from outside of the automotive and custom motorcycle industries. You have to stay fresh. People go to car or bike magazines for inspiration, but then they just recycle ideas. The art museum is good. The fashion industry comes in handy as there are so many top designers to choose from. The challenge is to find a way to start with a design that's on canvas and take it to metal, you need different products, and processes.

Do you pre-plan the design?

I always start from a tight center and work my way out, there is no true pre-planning other than to decide how much space it's going to take up. If you go too far out to begin with you have a lot of space to fill. Better to start tight, you can always add a bit if you need to.

Knowing when to say when is important so you don't add something to a design that you wish later you hadn't. I like to look at it, step back, and ask 'is there anything I can do to improve on that?' In the case of a graphic design, the pinstripes can really pull things together.

What about the brushes you use?

I used Mack brushes for many years. Then I came across a Scharff brush, I like them a lot, but they

shouldn't be your first brush. With a Mack you can work off tip, others you can't. When I bought my first Xcaliber I was skeptical, now it's all I use. They are much smaller brushes, they hold their shape better and don't flop around. It takes getting used to in the turns. You have to get used to rolling it in your fingers differently.

How do you keep them in shape?

I thoroughly clean the brush, because otherwise it starts to get dry at the heel. If I'm using One-Shot I use mineral spirits. If it's urethane, I use urethane reducer. When you finish the job, comb it out with an acid brush. I store them with a light coat of oil, laid out flat on a hard surface with the tip laid out.

What do you like for paint?

I like One-Shot for lettering or pinstriping. The only Urethane I use is from House of Kolor, those flow really well and dry quick. You don't have to wait with the second color, and you can clear it without any trouble at all.

Ten words of advice to anyone who wants to get better?

Practice, patience and perseverance.

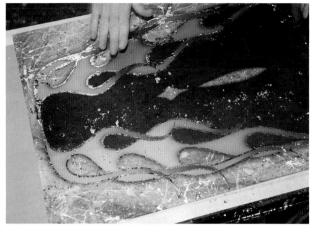

After all the leaf is in place, gently remove any excess.

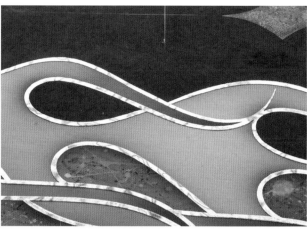

The leaf's nice clean edges separates the flame licks from the background like nothing else, and brightens up the entire panel.

Next, I use a soft cloth to clean up the edges and remove the rest of the excess leaf.

Now for some conventional striping. Using the Stabilo lines as a guide, I begin the design. The first color is H of K violet (U 29).

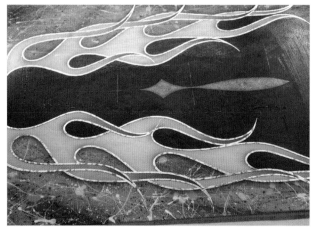

The leaf work is done and the desired effect is achieved.

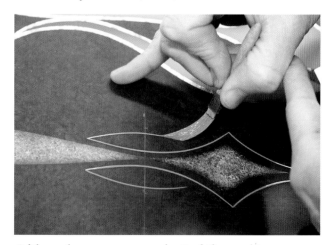

I like to keep my eyes on the Stabilo markings to keep the design symmetrical.

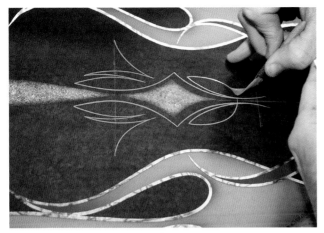

I keep the design tight at first.

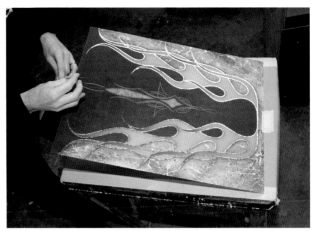

Now for the top part of the design.

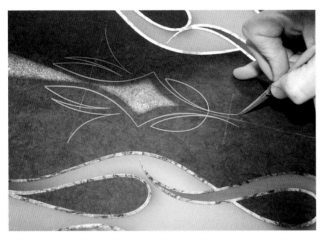

It's easier to broaden your design than to try to bring it back in.

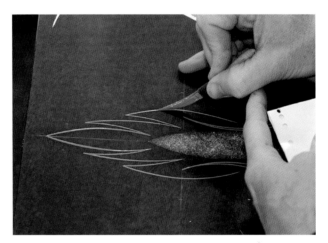

In this instance two separate designs must connect and act as one. I try to keep this part of the design basic...

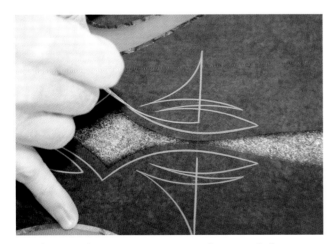

Make sure those connections are sharp and clean.

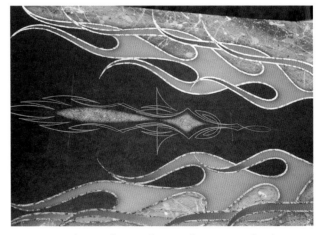

...so I can have plenty of room for more color later.

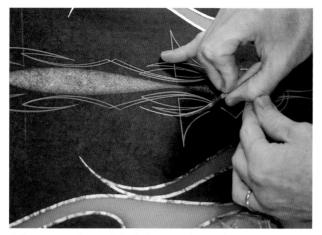

The next color is H of K aqua (U 31).

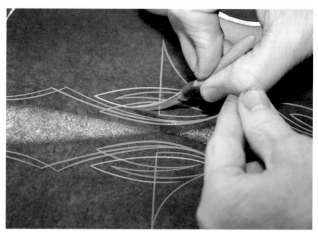

I steady my hand by using the pinky finger of my right hand, and my other hand.

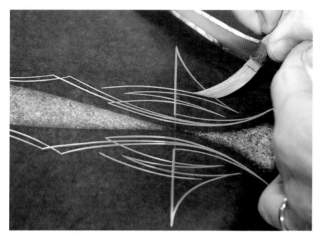

I use the previous lines as guides to expand the design.

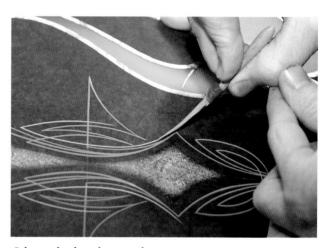

I lean the brush into the turns.

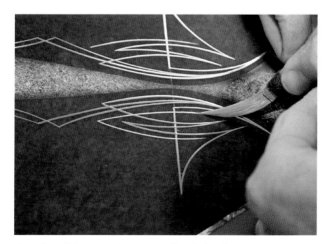

I only add one stripe per side of the design as I go back and forth. This helps keep track of where I am.

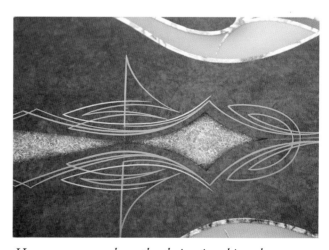

Here you can see how the design is taking shape.

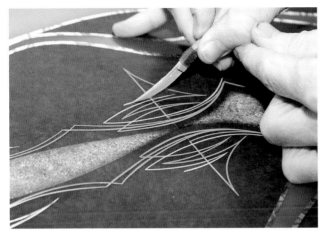

Here I'm building on the design with balance in mind.

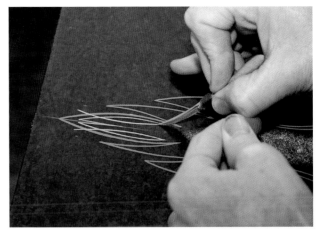

Now I go back to the top of the design.

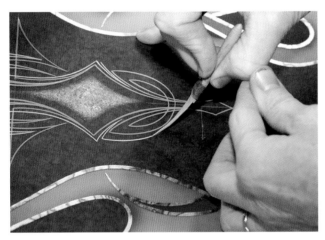

I usually work on the left side first so that I don't have to look under my hand to see what I've done.

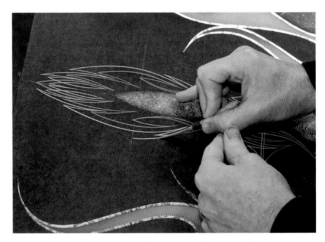

Remember we have to keep everything in balance and connect the top with the bottom of the design.

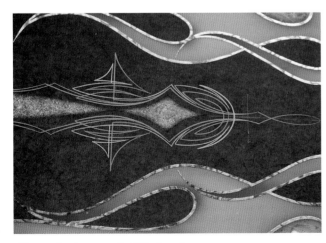

Here, the bottom half is in place.

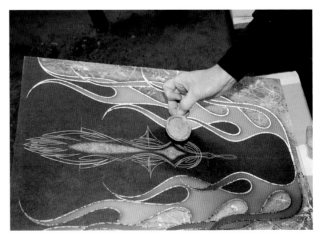

Time for the next color, after checking as shown I choose peach (U 28) from H of K.

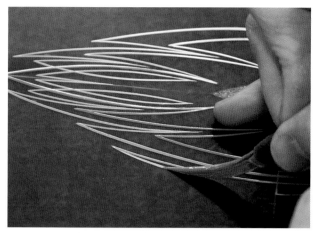

Now I can begin to widen out the design.

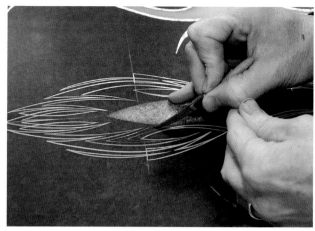

Now for some House of Kolor magenta (U 14).

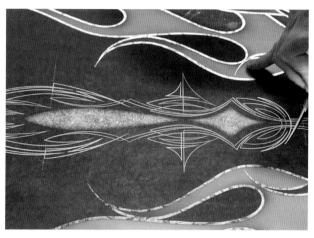

A little bit of this color will go a long way.

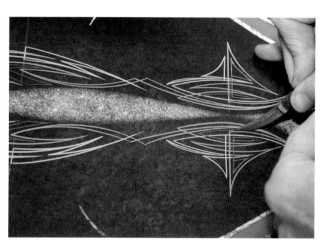

You have to be very careful as the design gets tighter.

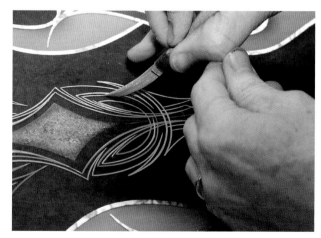

I add some to the inside of the design too.

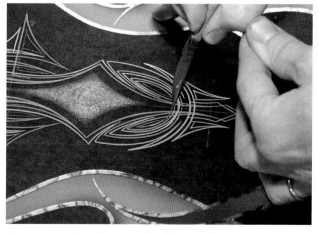

Some very thin lines will add nice detail.

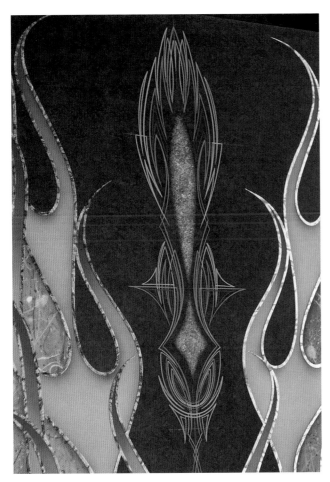

At this point the design is almost complete.

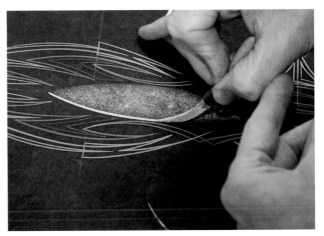

The "sponge" design gets outlined also, here I put on size before adding the leaf.

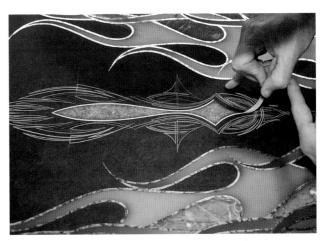

This area will be outlined in silver leaf to add yet another element to the design.

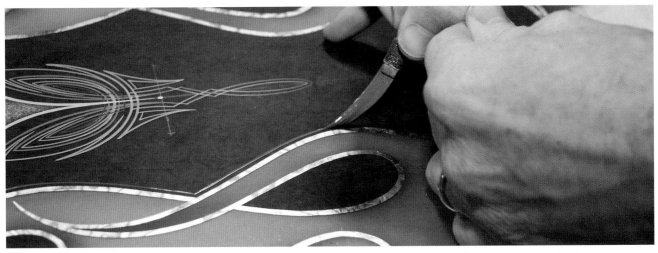

While the sizing sets up, a thin blue green (U 16) H of K stripe is added as a double outline to the flames.

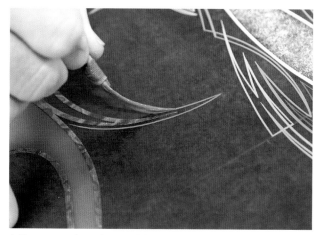

This second outline adds fine detail to the flames.

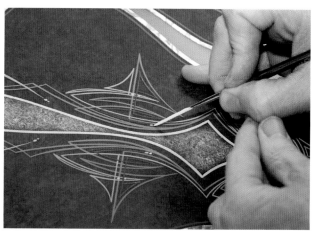

They can even be done with the sizing so you can have some leaf dots as well.

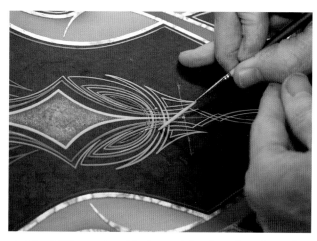

A Mack Virus, size 00, is used for fine details and accent dots. The green neon is so bright it doesn't take much to make a nice little hot spot.

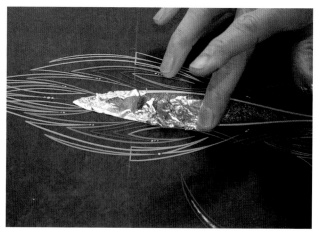

The size has set up enough that I can apply the silver leaf.

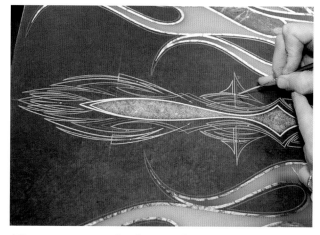

These accents can be done with any color and will give good close-up detail. Orange neon is the color being used here.

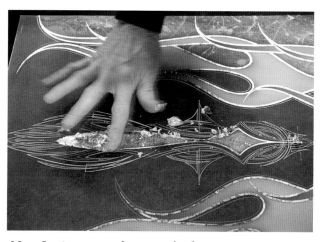

Now I wipe away the excess leaf.

The center of the panel is done and offsets the flames nicely.

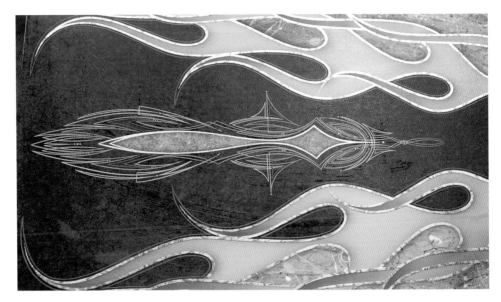

It's time to address the panel to Vince Goodeve as a gift. I want this lettering to look "sketchy." Note the white highlights.

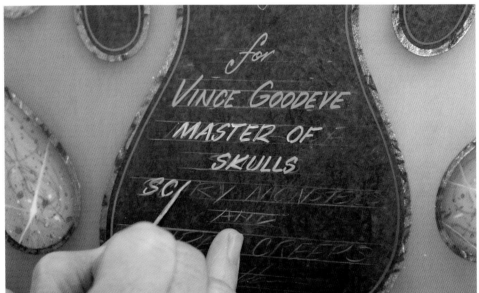

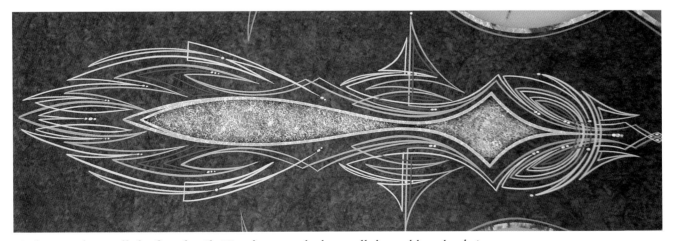

A close up shows all the fine detail. Note how much the small dots add to the design.

41

Chapter Four

Robert Pradke

Young Hands/Old Skool Skill

It might seem hard to create a powerful pinstripe design by using only one pinstripe color, a color that's close to the color of the object being pinstriped. As you can see here, however, to assume anything makes an ass out of u and me.

The underlying paint is candy tangerine, a three-step paint job using materials from H of K. The pinstripe color is a custom-mix orange make-up of H of K urethane striping paint. Before doing anything else, Robert wet-sands the tank

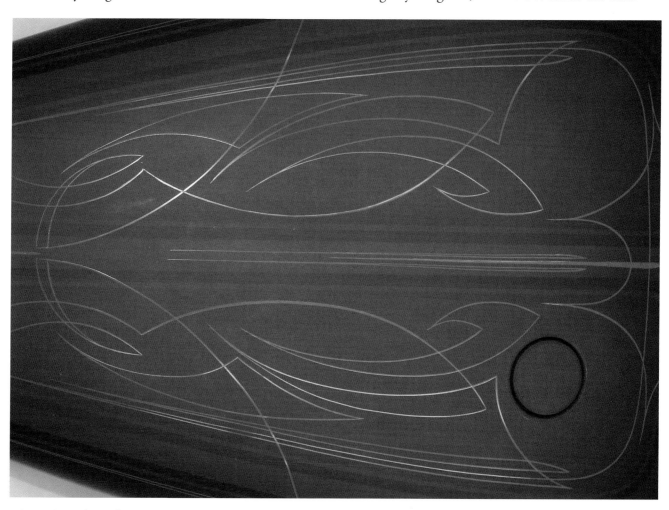

It's amazing how dramatic a pinstripe design can be, especially one that essentially places orange stripes on an orange gas tank.

All captions by Robert Pradke

with 1000 grit paper, then wipes it down with water-based cleaner.

The design started as a sketch on paper. Once he's happy with the design, Robert uses a Stabilo pencil to draw the sketch out on the tank. "I like to use the Stabilo pencil, it's water based. A water-based cleaner will take the Stabilo-lines off."

Robert is very exact in his work. The stripes themselves are as perfect as a hand-drawn stripe can be, and the spacing is very symmetrical. "Some guys work free hand, explains Robert, without any guides or sketches, but I like to work with more precision. If I see one line is a little higher on one side than the other it drives me nuts."

As he works, Robert tends to draw one line, then go to the other side and draw the same line, "that way I finish one section at a time, and it's easier to draw a certain type of line twice than to draw one, then move to something else, and then have to come back and draw that same earlier line again."

Though some stripers use multiple color layouts for more impact, Robert Pradke has other ideas. "I tend to keep my layout simple and use one color. My stuff is a little more structured, I don't work a lot at shows. At shows you don't have time to reflect on what you're doing.

If, during the striping, he doesn't like a particular line, he just wipes it off with H of K U 00 reducer (meant to be used with their striping paint) and starts over. When asked what makes a good pinstriper, Robert explains that, "A lot of this is like a pool game, you have to be thinking three steps ahead."

Using tape might seem like cheating, but like a lot of stripers, Robert often uses fineline or thin masking tape in certain situations. "I use the tape as a straight edge, I don't ever actually touch it."

With his trademark precision, and a degree of patience, Robert covers the gas tank with lines that definitely fill the space, a pinstripe design that is intricate and complex without being busy. The rest of the story is best told by the photos, and Robert's own captions.

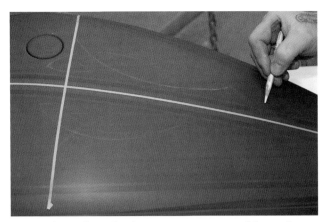

I start by pulling fineline tape in a vertical line, then a horizontal line. Stabilo pencil is used to lightly draw my design, so once I start striping I can spend my time on line quality rather than line placement.

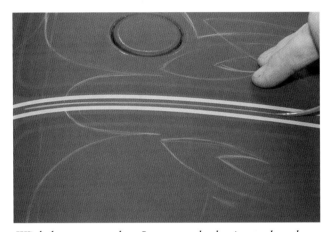

With layout complete I remove the horizontal and vertical tape and run two new lines of tape down the center. This stripe layout follows the candy panels I sprayed earlier. Placement of center lines is critical.

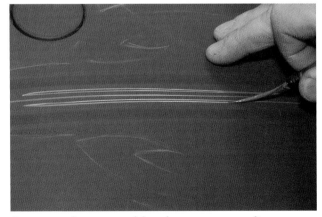

I remove the tape and lay down two more lines, one on each side of the center - keeping in mind the distance from the center. It's important to watch your stopping and starting points.

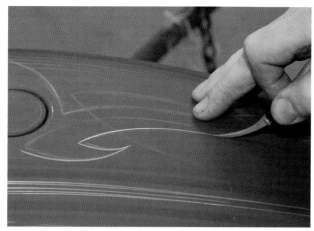

Working from side to side I start to fill in my design. This is what I call a floater piece. It floats in an area to consume space...

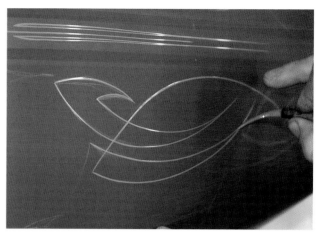

Points help change the direction of the line and fill up an area.

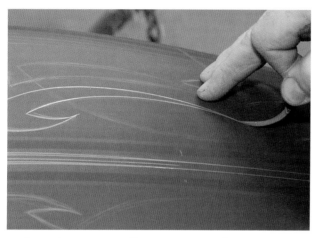

...these elements usually mimic a nearby curve or shape. Later it will be tied in to the rest of the design with a clean intersecting line...

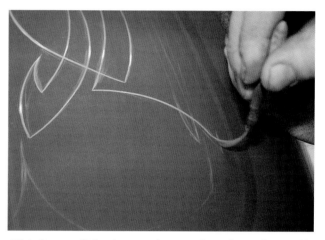

This line will lead in to the nice long lines that will accent the curve of the tank.

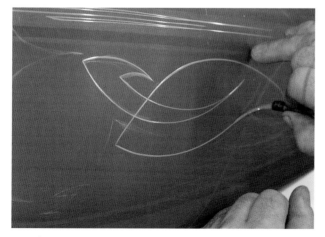

...which ties the shapes together without getting sloppy.

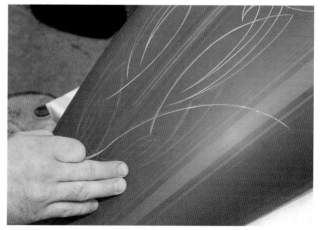

The long line seen here will connect the main pin-striping panel to the stripe work to be done on the sides.

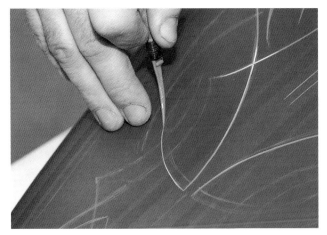

This is the start of a loop line...

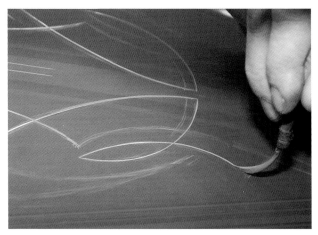

I'll pick the end of this line up a little later. It will help bring the design to the bottom of the tank.

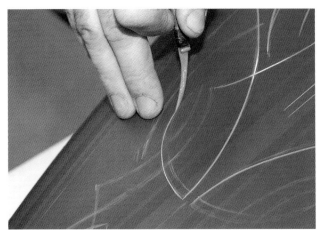

...keep a good curve in your line, you don't want to see any flat spots.

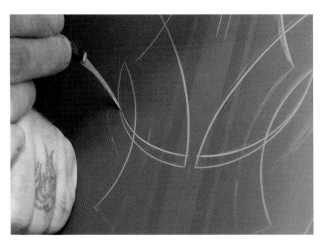

Pulling a second line will bring more attention to the upsweep.

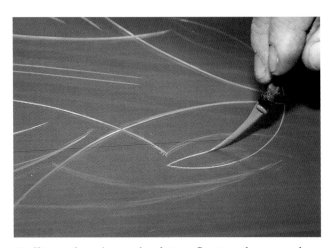

Pulling a loop keeps the design flowing downward.

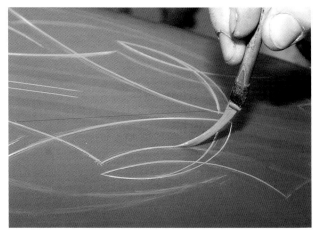

Picking up a line from above and bringing it down maintains the curve of the line beside it.

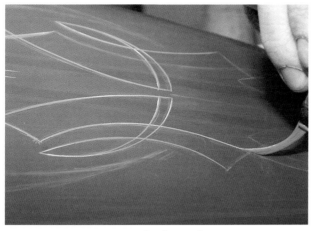

Here I'm connecting to the lines above, maintaining the flow downward.

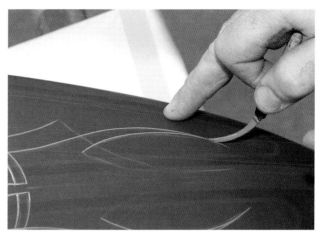

Try and mimic the closer of the points.

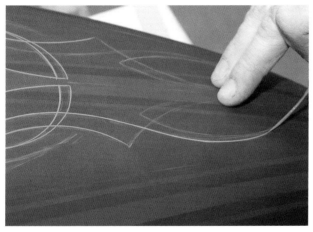

I pull some long curved lines down from the upper part of the design.

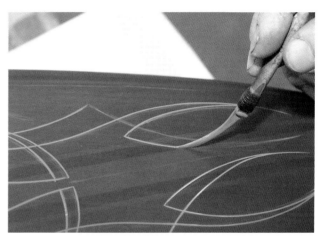

Here I mimic what was just done on the other side...

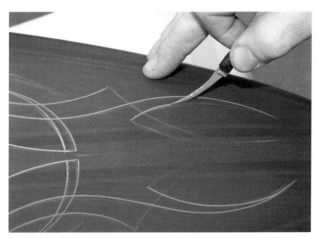

Always pay attention to the other side. I tend to draw one side, then the other.

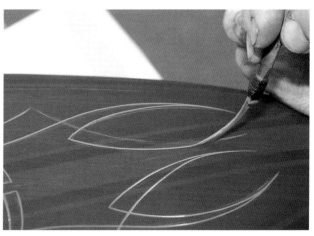

...following my drawing I did with the Stabilo pencil earlier.

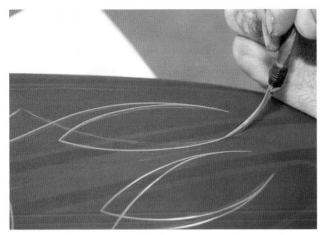

Here I'm finishing up the lower part of the tank...

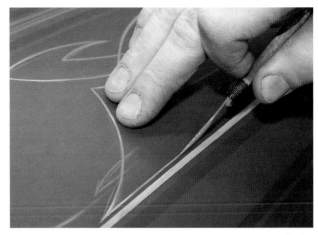

I use the tape as a guide line to space my line off the other.

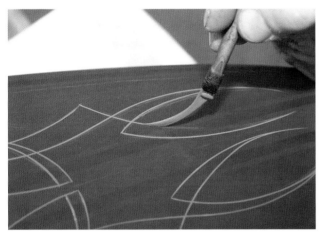

... and closing the open line I left earlier.

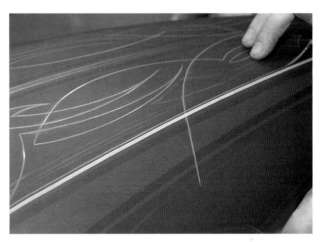

I like to incorporate long lines in with my stripe work. They tend to highlight the natural shape of the tank.

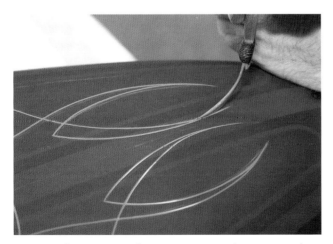

I try and pay particular attention to the open and closed areas of the points.

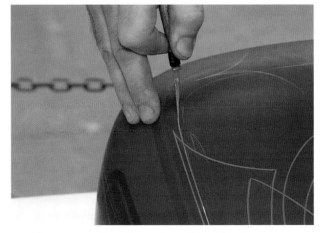

I'm bringing a line from the side to the front. This will tie the very front of the tank in with the rest of the design.

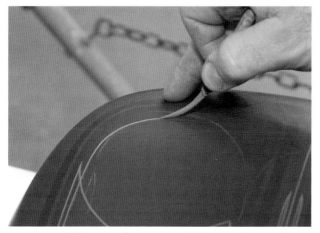

Here I'm following the curves of the candy panels...

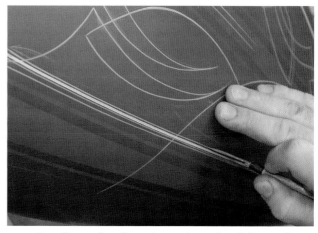

...as I pull another line down the side of the tank.

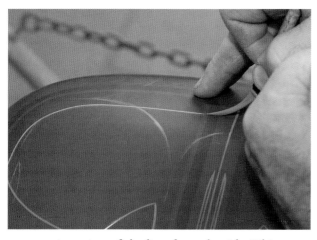

...a continuation of the line from the side. This connects with the center piece I did first.

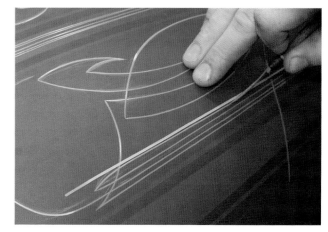

This piece of fineline helps me come back in to the previous line at the correct angle.

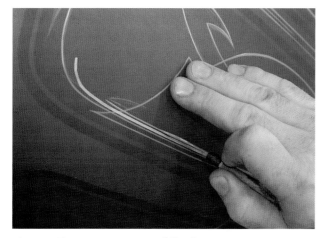

Again, I'm using a piece of fineline as a spacer...

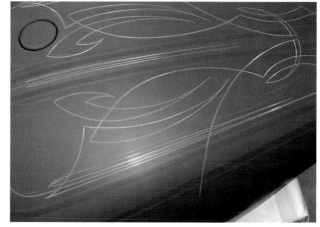

Clean intersecting lines and evenly run parallel lines work well with the paint job underneath.

Q&A: Robert Pradke

Robert, how long have you been on your own as a painter and pinstriper, and where did you learn the craft?

I've been on my own for 17 years. My Father was into fifties style hot rods and customs. By the time I was fourteen I was working on my '55 Ford. My father was probably the biggest influence on me. And then there are the traditional icons, Ed Roth, Tommy the Greek and all those guys. All the pioneers who made this industry what it is. A lot of what people are doing now is a morphed effect of what the old masters did. The original guys started from nothing.

Do you have any formal art training?

No, just high school art, and whatever I picked up on my own.

You do more than just pinstripes and graphics?

Yes, I do all of it, from the welding to the bodywork to the primer, the candy, and of course the pinstripes.

Can you talk a little about your design ideas?

I try to be as original as possible. In my pinstripe designs I try to achieve a balance between space and color.

Do you have a mentor, or someone you looked up to?

There's a local guy, Doug Gagnon, he's the one who taught me the most. The pinheads helped too. I guess I've grabbed what I could from wherever I could.

Tell me about how you thin the paint as you're working, how you get it to the right consistency?

Urethanes tend to dry much faster, it's a basecoat system so they flow differently than One-Shot. I tend to thin urethane more than One Shot. And it depends on what I'm trying to accomplish. If you thin the urethane more it's easier to pull a long straight line.

What do you use for paint?

Either One-Shot or H of K urethane. If I'm going to clear the parts, I use urethane, I don't take any chances on having something blow up on me. I don't add catalyst to the urethane.

What about your brushes?

I like Xcaliber brushes that I cut up. I tend to use those with urethanes because they're more controllable. I sometimes use the traditional long brushes with One-Shot, it depends on how I feel. Every brush I get in my hands I cut up, I try to take a lot of the belly out. As they get smaller they get shorter, so for example I might take a 0 Xcaliber and cut it down to a 00 or 000 so that way I have a 00 with more length.

Any advice to pinstripers who are trying to get better?

You have to put in the time behind the brush and you need the sincere desire to improve your striping. Some people get to a certain point and they're satisfied. Others keep striving for something more.

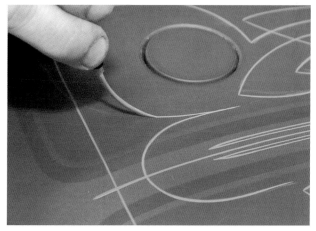

Going back in, I start to fill in the front of the tank.

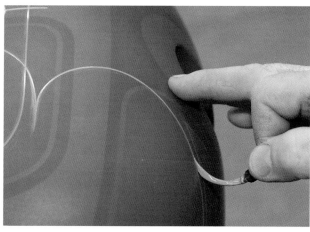

...always watching the shapes underneath.

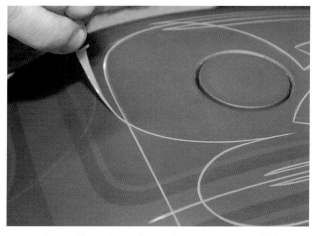

Now I'm pulling lines from the center toward the sides...

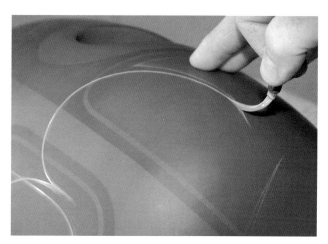

This is the last point for the front of the tank.

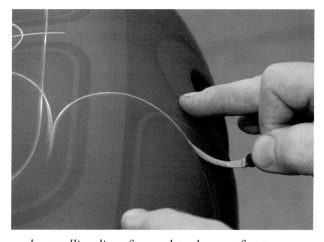

...then pulling lines forward to the very front...

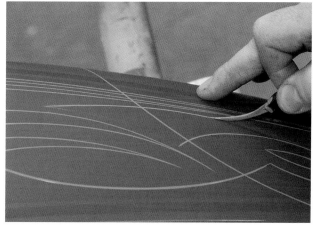

Now another floater piece is used to fill in some space.

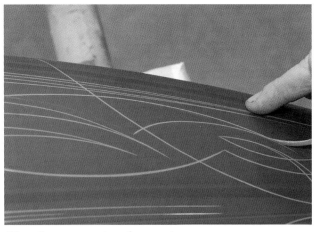

Here I create a nice clean point.

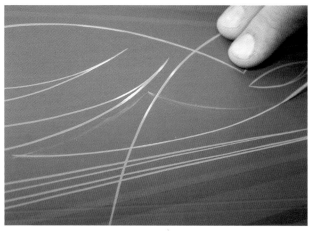

Now it's on to the other side to fill in.

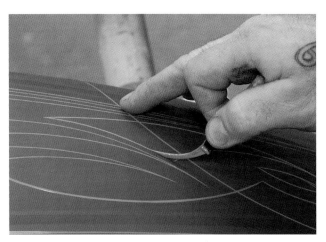

Then pick up the curves of the closest lines.

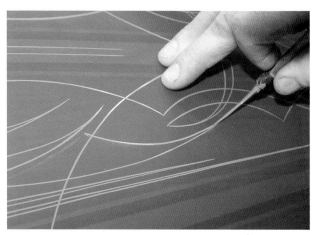

Again..I try and keep it exactly the same as the other side, the same stopping points, the same starting points.

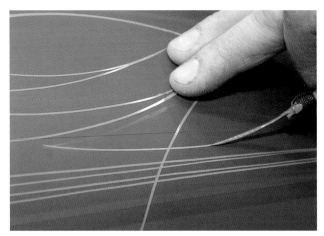

Even with filling in, I try to keep it clean and make it flow.

I use a covered board to support the tank. This way I can work on both sides without touching anything.

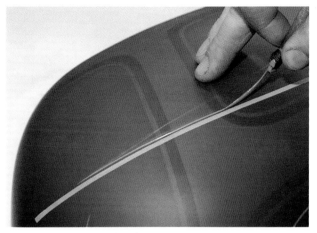

On to the other side of the tank.

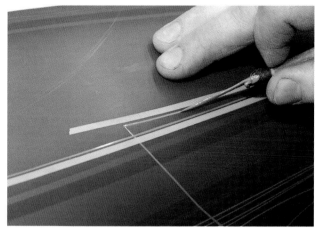

Here I'm connecting with the line I left earlier from the center of the tank.

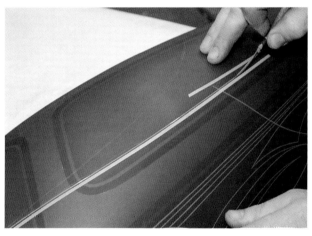

I'm laying down my fineline to pick up the line of the tank.

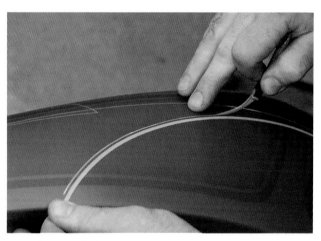

Another guide line insures a nice even curve and the correct placement.

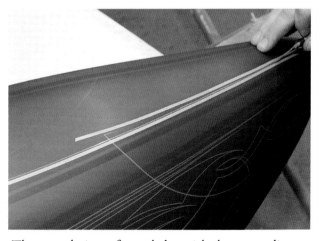

The second piece of tape helps with the return line.

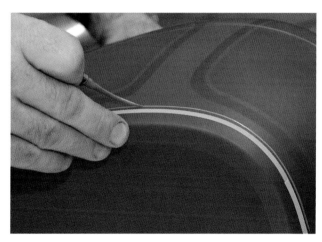

I run a line around the bottom of the tank...

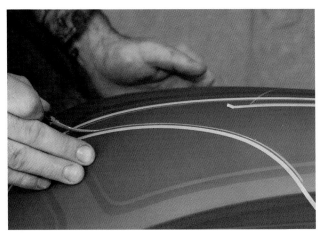

...coming back in to the upper side.

I use a modified Xcaliber brush for my stripe work and a Mack quill for lettering.

Clean curves and good line placement fill up the space I wanted to, without disrupting the lines of the tank

I put my tag on, clean some stuff up, and apply 4 to 6 coats of clear.

Running a line around the bottom of the tank, which also connects with the side stripe, ties the whole thing together.

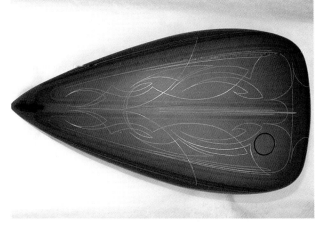

The pinstriping works with the paint job, not against it. The shape of the tank becomes a part of the overall job.

Chapter Five

Mark Peters

No starving artists here

If you ask Mark Peters how he became a pin-stripe artist, he explains that, "This is what you do if you've got a strong hankering to be an artist, to put paint on canvas, to express yourself in colors and inks, but no way to sell the resulting art, and thus no means of supporting yourself. When I got out of the military I wanted to do art, but the starving artist thing didn't hold much appeal for me, that's why I started pinstriping, mostly on cars."

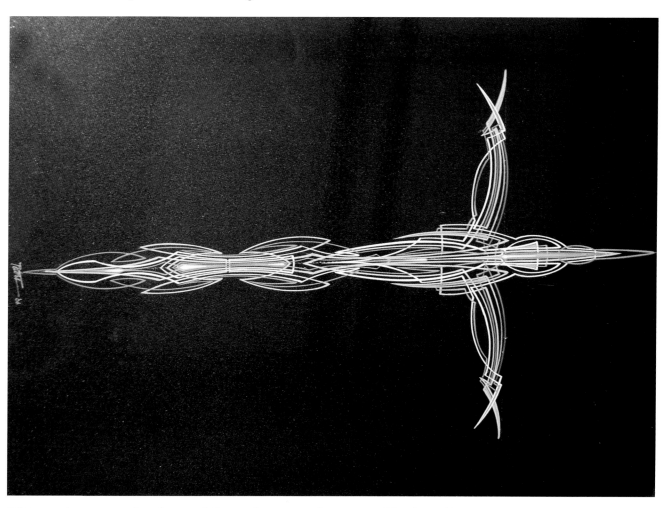

This panel was started without a definite plan in mind, in a case like this, I'll wing it.

All captions by Mark Peters

Mark crossed paths with Wolfgang Publications at East Coast Artie's shop in Myrtle Beach. Artie suggested to Mark that he become part of the book, and the rest is right here in front of you. Because Mark arrived by motorcycle for the Myrtle Beach Bike Week, and didn't plan to do any striping, he was forced to work with Artie's brushes and paints. Not that there's anything wrong with Artie's equipment, it's just that most of us like to work in our own shop with our own tools.

Mark starts this panel by running a centerline down the center. The color is One-Shot light blue, lightened up with a little white. "I like Mack brushes," explains Mark. "Often I start out with a number one or two, for a car it's a two. I might use an older Mack, one that's lost some hairs and that I've trimmed. Sometimes I take an old Mack brush and pull the hairs out of it and re-tie them, like tying flies, and make myself a real nice little brush."

The next color is Aqua 149, mixed with a little white and a little of the light blue, as Mark explains, "I don't want the aqua to be so bright it will overwhelm the blue. It's taken me years to figure out what goes with what. You have to work at it, practice to get things that you really like. Once you get one or two colors on the panel you can tell which way it wants to go."

Mark often uses the butt end of the brush, with or without a piece of towel on it, to clean up mistakes. He also explains that if one line of a pair of parallel lines is off a little, you can correct the situation by widening both lines. "I can pull one in one direction and one in the other and correct their positions in that way."

Mark is careful to keep the design the same from one side to the other, and to leave open areas between the lines that he can fill in later with color for an added accent.

Speaking of accents, the next color, a cross between hot pink and fuscia, really livens things up on the panel. Mark uses the color to brighten the design, without overwhelming the work that's already been done.

Some of the spaces Mark left between the lines

I started this design with a double stripe about half way down the panel.

As all stripers know, it's one side, then the other.

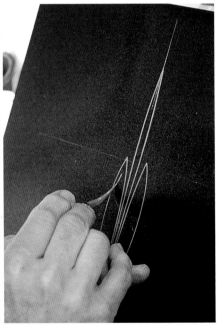

A few simple lines to get the design started. Stripers new and old develop their "startout" techniques.

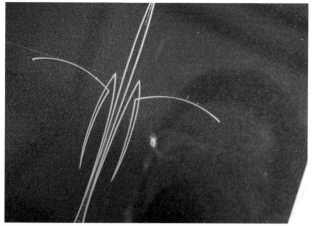

Not a bad start for my first time at this, is lunch ready?

I always palette my paint on a card with a Mack #1 or #2 brush. Design starts with One-Shot light blue with a little white to bring it up off the blue panel.

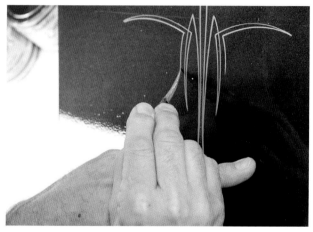

I like to support my striping hand with my left. Take measurements if needed. You'll eventually learn to do it by eye.

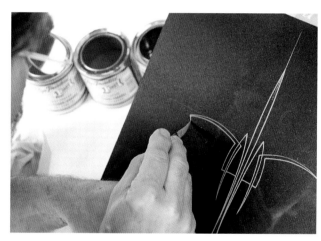

This stuff is great on hot rod deck lids, bikes and lots of fun at Panel Jams.

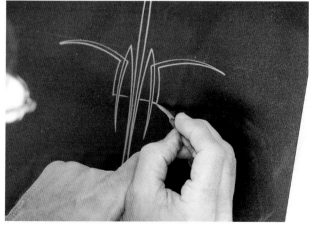

When learning to stripe, you will develop your own comfortable way to hold the brush.

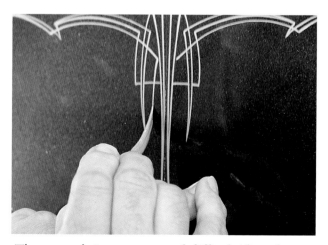

These type designs are not real difficult if you keep the lines short. Left side is easy, now match it on the right.

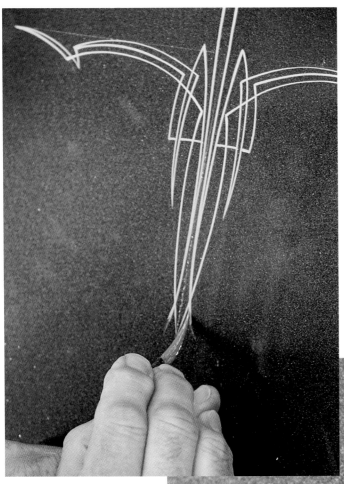

are filled in next, with orange in this case. No, orange doesn't sound like the color you'd want to mix with the primarily blue pinstripe art, but one look at the end result and all doubts are eliminated.

In case the orange isn't quite bright enough, Mark uses just a very small amount of bright yellow to provide your eye with one more hue to try and absorb while viewing this intricate pinstripe panel.

Perhaps the most surprising part of the process is the precision with which the lines are laid down, and how quickly Mark takes the design from a simple series of lines to a full-blown and very colorful piece of art.

Notice I have used only one centerline as a guide. You can use more. Keep your eye on spacing and distance.

Half way down an 18 inch panel, I start over on the second half.

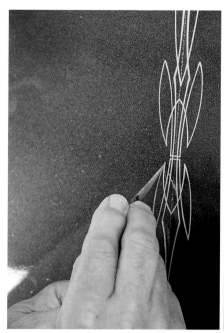

Keep the base design simple. There's going to be opportunities to add to the design with other colors.

How about some aqua. I can't go wrong with a lighter tone in the blue family for a second color.

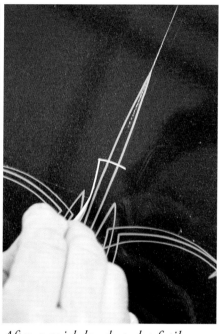

After a quick break and a futile attempt to collect an observation fee from everyone, I start in again.

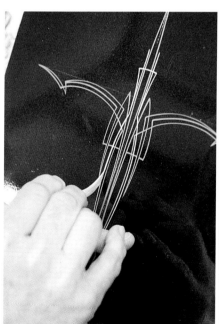

This time I have multiple guidelines, I'm very careful with the spacing.

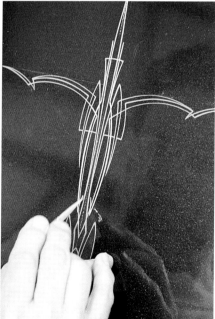

Nothing real fancy, here I'm just adding contrast.

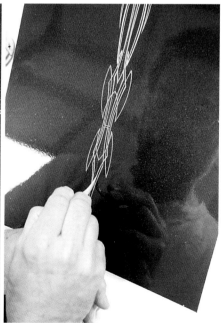

I don't get wild at this point, upcoming colors will do that.

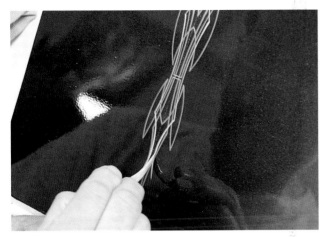

Here the design starts to take shape. Remember, I'm still wingin' it.

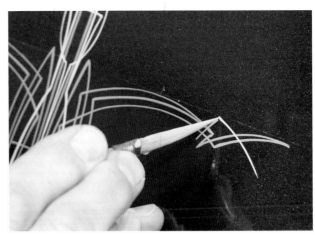

Sometimes, even I paint outside the lines. If it doesn't work, I've got a rag, and don't be afraid to use one if you're not satisfied.

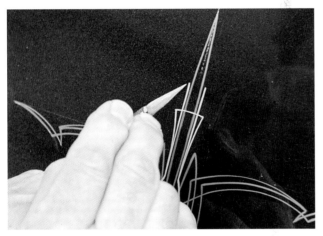

I add a little "conservative fancy" here since this is the top of the design.

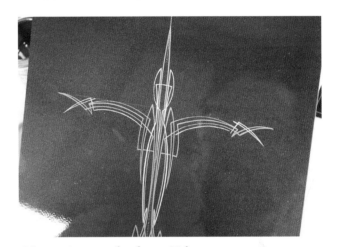

It's starting to take shape. Take some measurements.

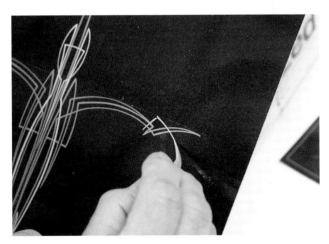

Keep in mind you have to leave spaces or create open areas for the fill-in colors.

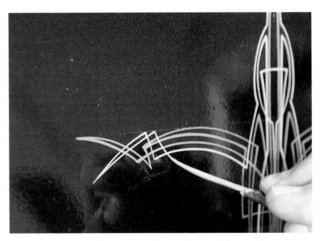

There is an infinite number of possibilities that a design can take, sometimes you can actually get paid for this!

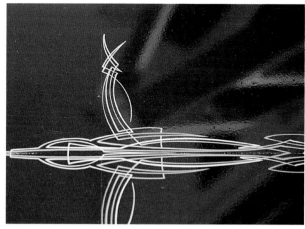

This is a good time to check it over, and look for possibilities.

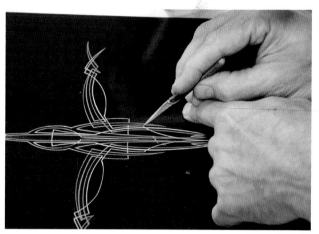

I tighten up the corners and points for a clean design.

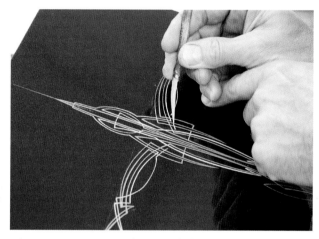

I'm connecting some loose ends here while I'm thinking ahead to the next move.

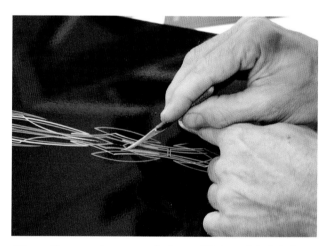

Here, I'm creating some holes to fill in with brighter colors.

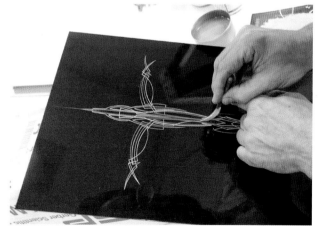

I "wing" in a couple lines in the large open area near the center.

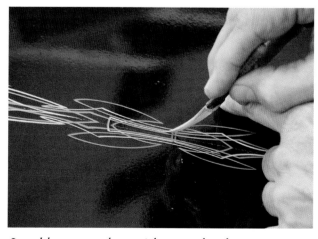

I could go on and on with aqua, but lets try some complementary colors next.

Q&A: Mark Peters

Mark, how did you become a pinstripe and panel artist?

I started with an art background at an early age. By 1974 I set my sights on a career in the sign business. It was the quickest way to get my art out there where the public could see it. Over time, one phase led to another and now, thirty two years later, I have become known for hand brushed art, motorcycle graphics, pinstriping and fine art prints. This combination has led to a fusion of fine art with street graphics. Panel art is the perfect medium in that anyone can own a nice piece of art. And I've begun to offer some of this art for sale as limited production prints. These days I work out of my shop at home in Asheville, NC.

Where do you get your inspiration and ideas?

I see stuff everyday. I look for ideas in magazines and at car shows. Panel jams are good, we all trade ideas. Sometimes I develop a real basic concept and just go from there. I'm always looking for new ideas. After so many years I've developed a style, I strive for something that looks like maybe it came on the car, like it belongs there.

What do you like for brushes?

I always use Mack striping brushes for pinstripes. When it comes to panels or small striping, I use a number two or three quill or one of the new Taklon brushes. Any of the little liner brushes with about one inch of bristles. That way they don't have the weight of the big floppy pinstripe bush, you can control them more easily that way.

What are your choices for paint?

I use One-Shot most of the time. With motorcycle work though, I've started to use House of Kolor striping urethanes. They dry fast and they're easy to clear over. Sometimes I put hardener in the One-Shot.

How do you choose color combinations?

Experience. I might use two colors, dark blue and light blue on a blue car. I stay with a color that's close to the base color, then I use complementary colors, and go from dark to light. I did this panel that way. With less striping as you go toward the lighter colors, and just a touch of the last, brightest, colors.

Final words of advice to pinstripers who are new or who want to get better at their craft?

Start with good brushes and One-Shot. A lot of people start with cheap brushes from the hobby shop and then they get discouraged. Get a hood or fender from the junk yard and practice on that.

There were some new guys at a panel jam recently, the rest of us all agreed in the advice we gave them, 'you have to develop your own style. Each person will hold the brush differently and have their own habits. Take those habits and work with them. And practice.'

Hey, lets try a hot color that goes with the blue, but ads some "pizzazz". Note the kool palette.

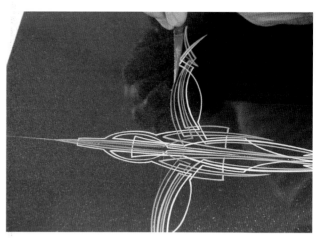

This magenta works well to brighten the design. Note how I filled in the open area on the tip near the brush.

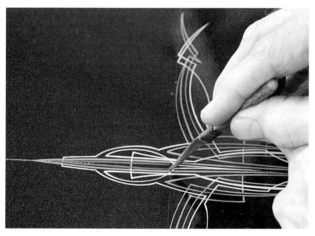

That doesn't look bad, of course I tried a small spot, got some confused looks and tried to collect another fee.

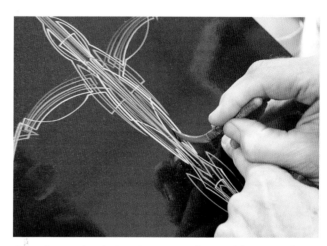

I go down the design just enough to add some color.

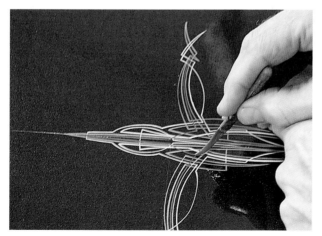

DON'T try this at home...Do it in public so you can hear all the comments like, "Is that a decal?"

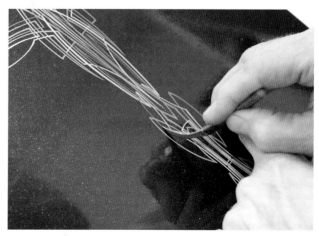

You can see where I started the second half of this design, check page 57.

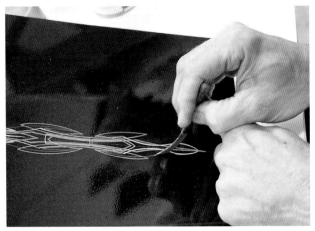

This space near the bottom looks like a spot where I can do some creative stuff, though I don't get too wild.

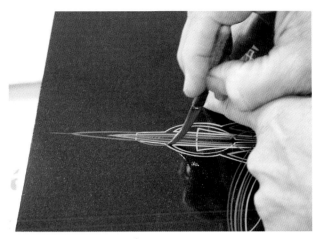

Lets put a crown on the top.

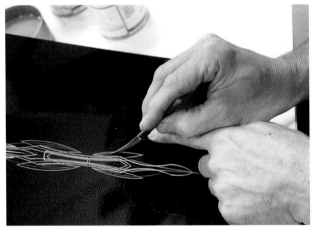

Notice I'm using short lines somewhat parallel to the blue lines.

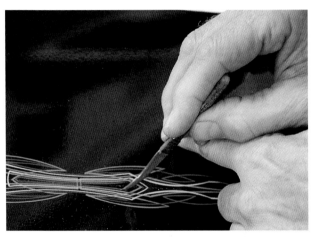

I fill in a few more open spots using the same Mack brush.

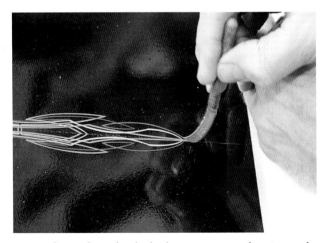

Near the end, sit back, look it over, see what it needs.

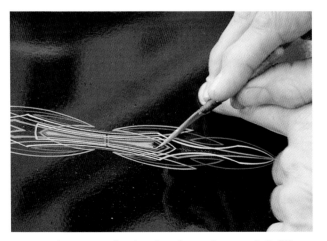

Now, it's time to further brighten the panel. I fill some holes with One-Shot orange. Sometimes I use a smaller detail brush if its a smaller design.

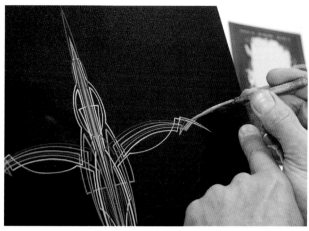

Filling these holes and open spots with a bright color really makes the design jump.

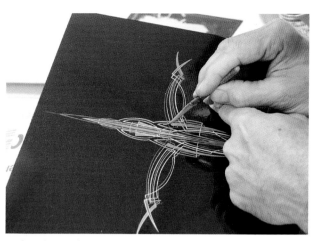

I finish up the orange to obtain a nice color balance.

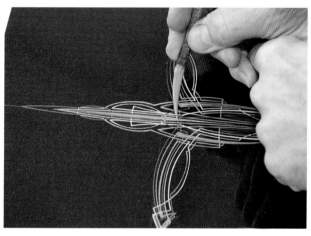

I connect those orange filled holes with a few thin lines, but sparingly, it's already pretty bright.

When a striper looks at you over the top of a pair of these, you know he has a lot of experience.

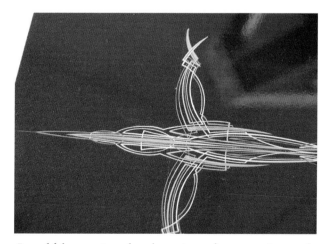

I could keep going, but knowing when to quit usually pays off.

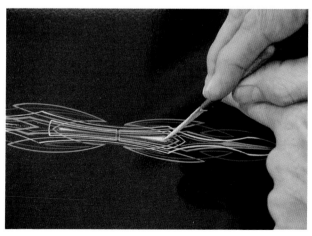

I'll finish it off by highlighting the centers. That yellow lays the whammy on the design.

You can't go wrong by starting out with subtle or cool colors, work up to the warmer colors, and highlight with something bright. There is no limit to the color combinations and design possibilities.

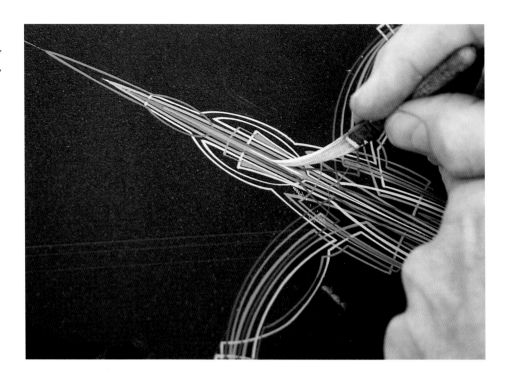

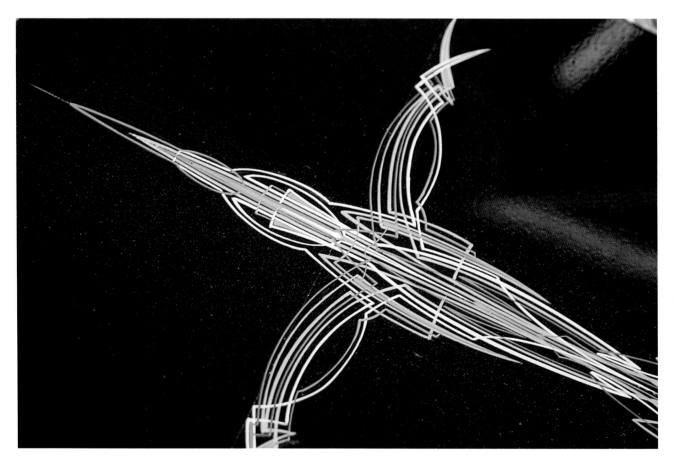

My thanks to East Coast Artie for the use of his shop and supplies to paint this panel. This art would look great on a hot rod or hanging on your wall.

Chapter Six

Nick Pastura

A Complex Helmet Design

Nick Pastura might be called the helmet man, as a significant number of NASCAR drivers come to him to have their helmets painted. When he's not painting helmets, Nick can be found painting, and even building, custom motorcycles. With a background in commercial body work, there isn't much fabrication, body work, or paint that Nick hasn't done and can't do.

Shown here is a helmet project done for Jamie McMurray from Roth Racing. While NASCAR

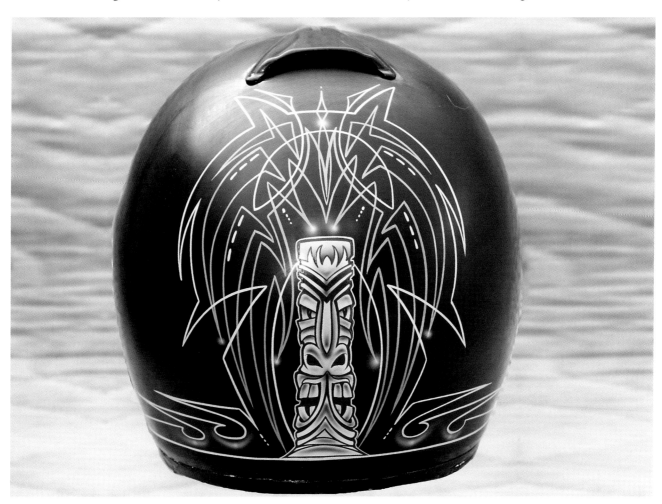

When NASCAR driver Jamie McMurray gave Nick Pastura a free hand to design and paint a helmet, what he got wasn't corporate logos done in exactly the correct color. No, Nick gave Jamie something truly unique, tiki-man!

helmets are often festooned with corporate logos and colors, in this case Jamie sent a test helmet, and as Nick explains, "Jamie just said I should put something crazy on it."

Something crazy turns out to be tiki-man, surrounded by a wild, thin-line design that fills the back of the helmet. What may be most interesting is the way that Nick first sketches out the design, and then traces it onto the helmet itself. Nick always finds the center of the helmet by eye, "you have to do it by eye, you can't measure because these are never symmetrical. And because they're so curved you can't just layout a grid on the helmet. That's why I lay it out on paper first."

"You can use Saral paper to transfer the image onto the helmet," explains Nick, "but it leaves more of a mess behind that you have to clean off."

1. "I start with black basecoat, which is then cleared and scuffed with 800 grit paper. Next comes the centerline as shown. I do this by eye, not by measuring."

2. "I sketch the design out on tracing paper, then go over the back side of the design with a yellow Stabilo pencil, this will transfer to the helmet...

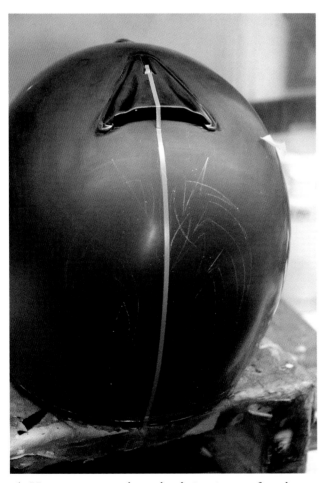

4. Here you can see how the design is transferred to the helmet. The pencils come in various colors so you can pick one the contrasts with the base color.

3. ...next, I tape the paper onto the helmet and go over each of the lines with a regular pencil. The pressure on each line causes the yellow pencil, which is on the backside, to transfer to the helmet."

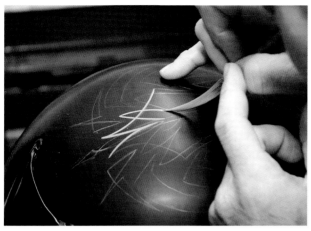

A tracing like this is especially nice for someone new, you don't have to work freehand. And you can use the design again.

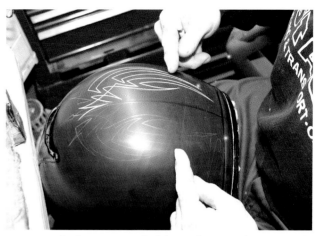

Even with the tracing, "I like to be sure that one side is in the same relative position as the other side."

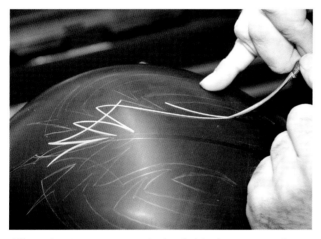

The color is a custom-mix buckskin brown, made up by mixing imitation gold with orange and black.

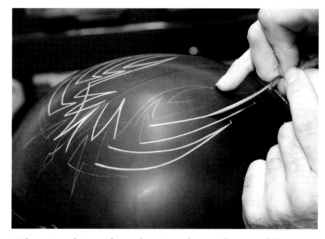

The nice thing about having the outline to follow, you don't have to follow a strict sequence as to which section gets done first or last.

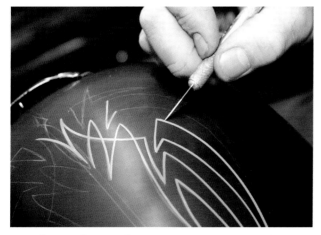

Small mistakes can be fixed with a razor blade.

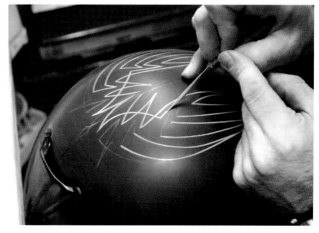

"If you're right handed though, it does help to do the left side of any particular area first, then the right. This way you don't reach across the fresh paint and put your finger in what you just painted."

What Nick does instead, is rub Stabilo pencil on the back side of the sketch, then tape the sketch onto the helmet, which involves folding the paper at the corners so it will contour to the round surface. To actually trace the sketch onto the helmet, he runs over the sketch with a regular pencil. The pressure from the pencil causes the outline to be traced onto the helmet. The lines are the result of the Stabilo material left on the backside of the sketch.

As Nick explains, "this is a good method for anyone who is new to pinstriping, because you end up with lines you can follow, you don't have to work freehand. In my case, it gives me repeatability. If Jamie likes the design I can easily duplicate it on a series of helmets.

The paint work itself is pretty straightforward. An interesting mix of pinstripe and airbrush work, all done in various shades of brown.

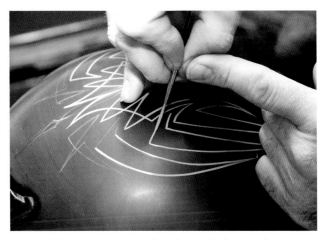

1. At this point, a short brush works better than a typical striping brush.

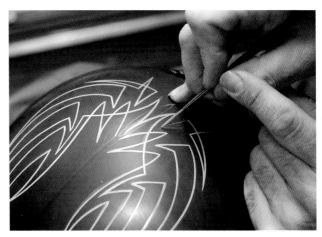

2. Any lines that are not covered by the paint can be wiped off with standard Windex, which is nice because it contains no ammonia.

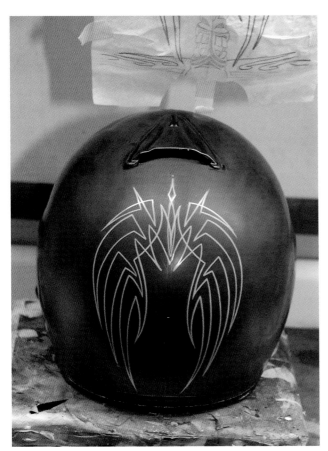

3. A progress shot shows this section of the helmet finished. Next Nick will add additional lines outside what's seen here and come in with a second color.

4. Now it's time to create a new color, a lighter brown created by simply adding white (02) to our current color.

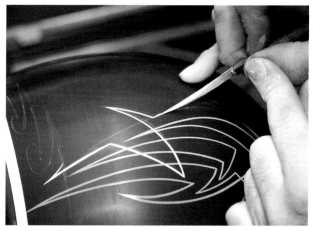

Here Nick has added to the design by drawing additional lines on the helmet, and then going over those new lines with the lighter brown.

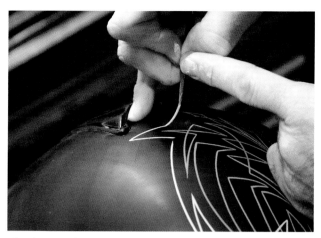

An interesting support system.

The colors evolve. Some of the new lines are done with an even lighter shade of brown. Here you can see three shades of brown.

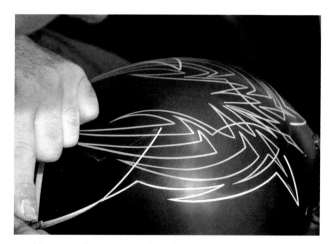

Still using the striping brush, Nick pulls the design to the side.

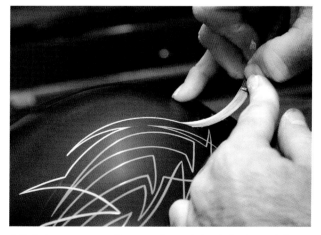

Nick keeps expanding on the original design with light brown, applied with a Mack striping brush.

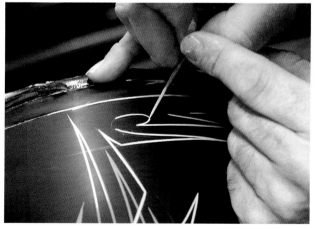

Nick does small scrolls like this with a short-bristle brush, which is not rolled through the turn.

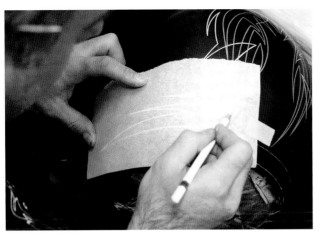

After doing a series of lines and scrolls on the lower left of the helmet, Nick goes over the design with a yellow Stabilo pencil.

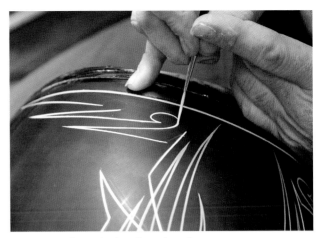

More work with the short brush...

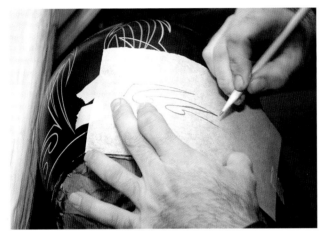

Then flips the paper, moves it to the same position on the right side, and goes over the lines with a regular pencil - essentially tracing the design onto the helmet.

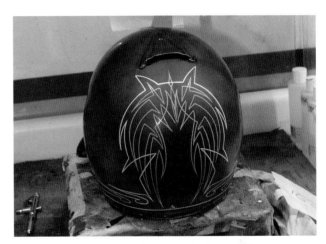

...and an assessment of the work done so far.

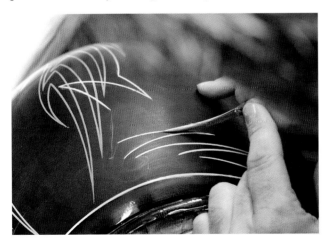

Here you can see (again) how the yellow of the Stabilo pencil was transferred to the helmet and is now painted with light brown.

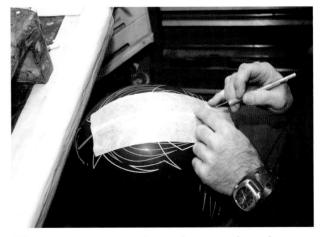

The next step is to mask out the area where the central part of the design will be created.

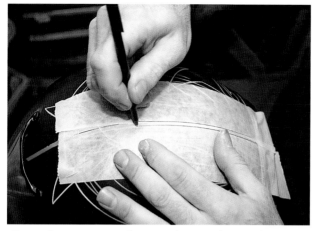

Once the tape is in place Nick starts by marking out the centerline.

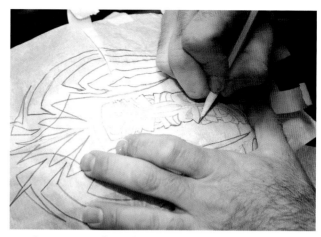

Nick goes over the Tiki-man part of the design with a pencil, pushing down hard enough...

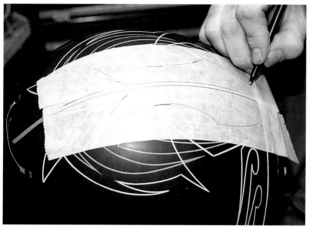

Next, he marks out the underlying design, these lines act as register marks so the original tracing can be positioned correctly.

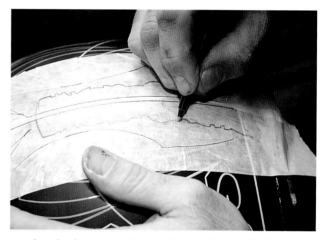

...that he leaves an impression in the underlying masking tape. Now he goes over the outline in the tape with a ballpoint pen.

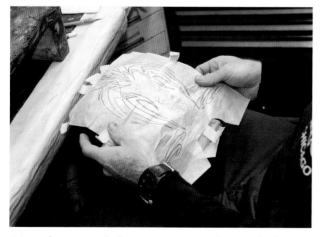

Now the original design is positioned over the back of the helmet.

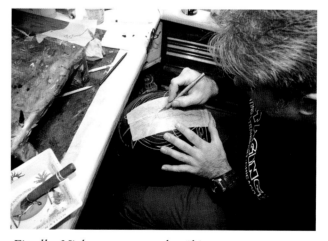

Finally, Nick can cut out the tiki-man.

Q&A, Nick Pastura

How did you get started as a pinstriper and airbrush artist?

That's the first thing I started doing after high school, I was standing over Chip Judd's shoulder (a local pinstriper) at hot rod meets locally. I wanted to try it, but of course I had no brushes. So I went out and found a couple. Two weeks later I went to a cruise night and did a pinstripe and gold leaf job. I practiced whenever I could, but mostly I just did it. I was doing bodywork and regular paint jobs at the same time.

It wasn't until later that I got into it heavy, I met Steve Wizard and Matt Willoughby at the Hot Rod Nationals. At that time I was doing more airbrush than pinstripe work. I saw them, man they were just whipping it out, so I wanted to do more. They took a little time to give me some help and then I started doing a lot of motorcycles and cars. I would go to local car cruise once a week. I was making four or five hundred bucks per weekend.

I did that for a couple of years, then I started doing bigger projects that weren't necessarily pinstripe jobs. But there is pinstriping involved in every job I do every day.

From helmet to motorcycle stuff, it all gets hand pinstriped someplace down the line, whether I'm outlining the flames or doing a pure pinstripe design or whatever.

Where do you get your ideas, your inspiration?

It's like I said before, I get ideas everywhere, all day, I'm always looking.

What do you like to use for pinstriping paint?

Mostly everything I do is buried under clear. Only one in seven projects are done in One-Shot. Mostly I use House of Kolor urethane striping paints with no hardener, again because everything gets cleared after the artwork is finished.

The drag of the H of K paint is nice, I like it. After using House of Kolor, the One-Shot seems too slippery, I can control the urethane better. One-Shot feels like walking on ice.

How about your preference for brushes?

I like Mack, and I like the Rafaels too.

What are the mistakes that novice pinstripers make?

They do lines that cross over. Lines that aren't consistent. They make points that aren't points, but turn into crosses. They put stuff everywhere, garaging everything up with a pattern when you don't need to.

I definitely like cleaner simpler designs. As far as I'm concerned, less is definitely more.

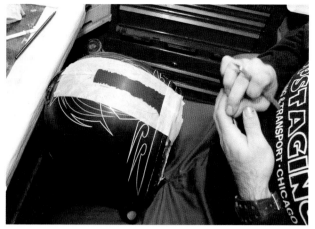

It took a lot of steps to get here, ready to start painting in the central part of the design.

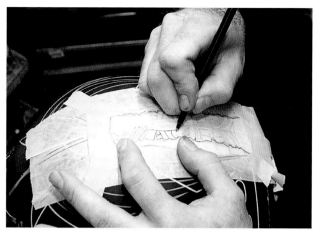

...and runs a pencil over the design...

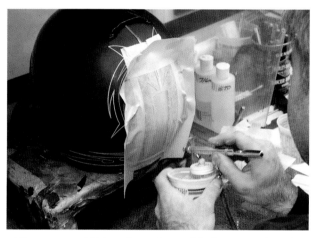

After some additional masking, Nick paints the tiki-guy area in a special-mix bamboo color, "You could do this with a brush if you didn't have an airbrush."

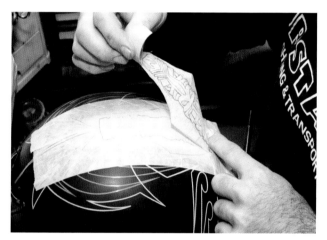

...which transfers the lines to the helmet as shown here.

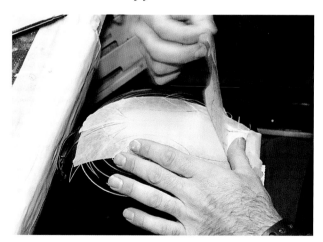

By now the pattern is familiar, Nick starts by taping the original design down over the helmet...

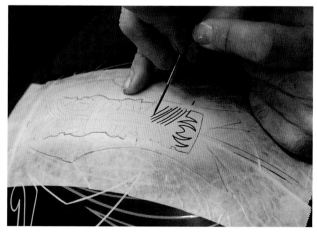

Finally, using brindle brown straight out of the can and a short bristle brush, Nick can begin to paint in all the details that make up the tiki-man.

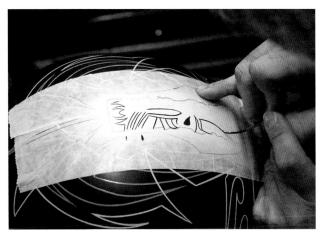

Nick turns the helmet around and continues the design...

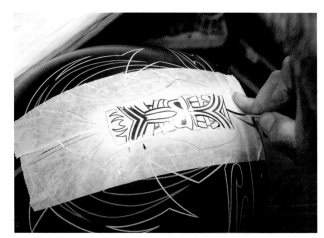

The final touch is a few thin lines at the bottom of the tiki-man.

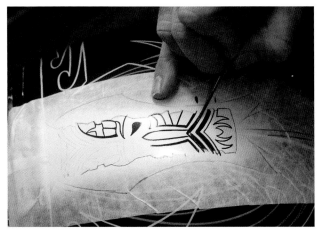

...still working with the short bristle brush.

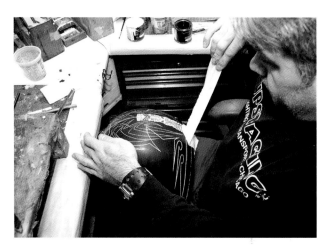

Time now to pull the tape...

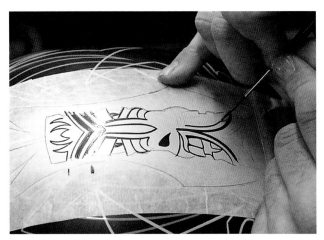

The process continues, as Nick adds light and heavy lines.

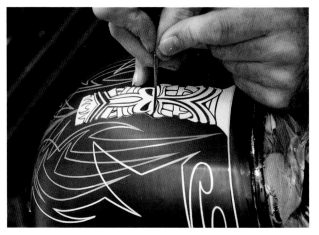

...and do a few final touch ups to the design.

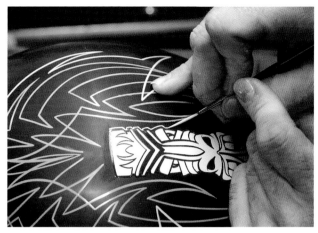

1. Using the lightest of the light browns...

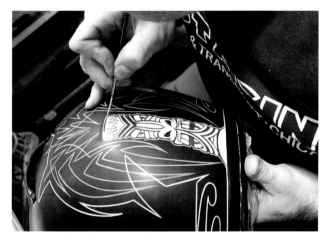

2. ...Nick outlines the tiki-man.

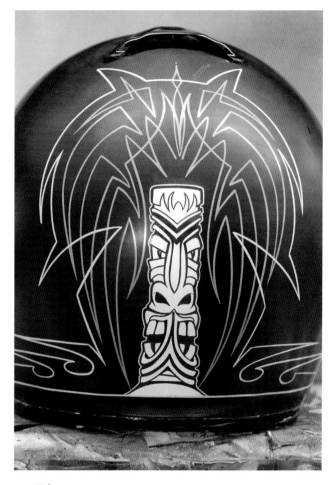

3. Tiki-man reigns supreme.

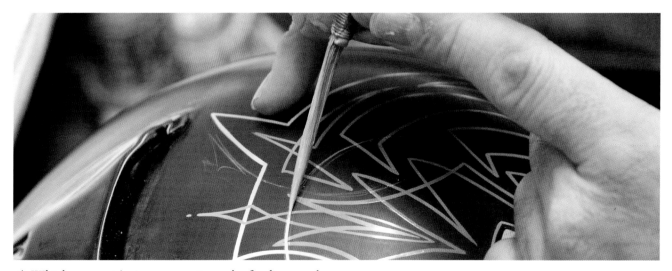

4. Which means it's time to continue the fineline work.

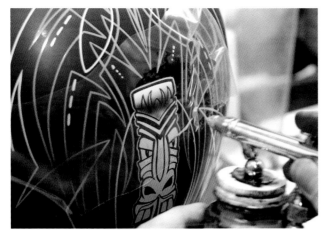

1. Here you can see the stretch mask, laid down and cut out before nick applies the transparent brown.

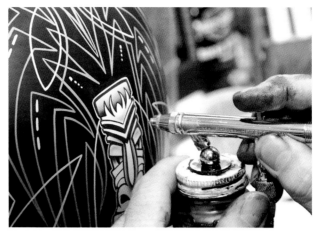

3. After removing the mask, Nick does a little more darkening working freehand.

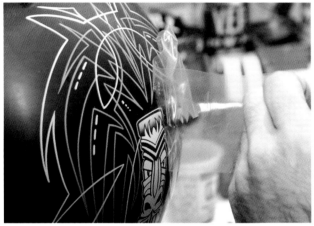

2. Here you can see the stretch mask being removed.

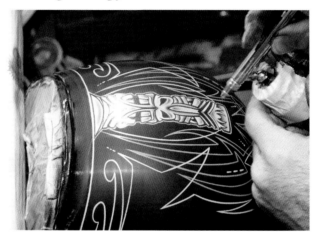

4. Again, no mask, just careful freehand work.

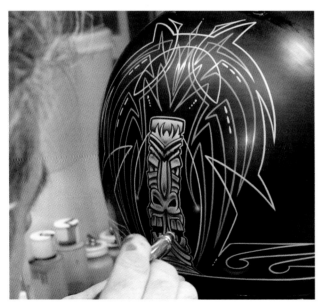

5. Nick continues with areas like the nose and teeth, darkening each with the same transparent paint, and without any mask.

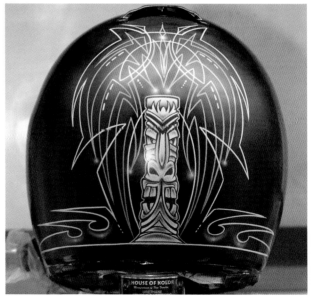

6. The finished product, an intricate pinstripe design embellished with a little airbrush work.

Brushes by Mack
Over 100 Years Old and Still Going Strong

The story of the Mack Brush company reads like the great American Novel. Only this story is true, from the pinstriper who founded the company and passed it on to his son, to the current ownership group, made up of another family.

Born in 1860, Andrew Mack worked as a striper at the J.J. Deal wagon factory in the 1890s. Andrew rose to be the lead striper at the factory and might have worked there until his retirement if it hadn't been for his dissatisfaction with the brushes issued to the stripers by J.J.

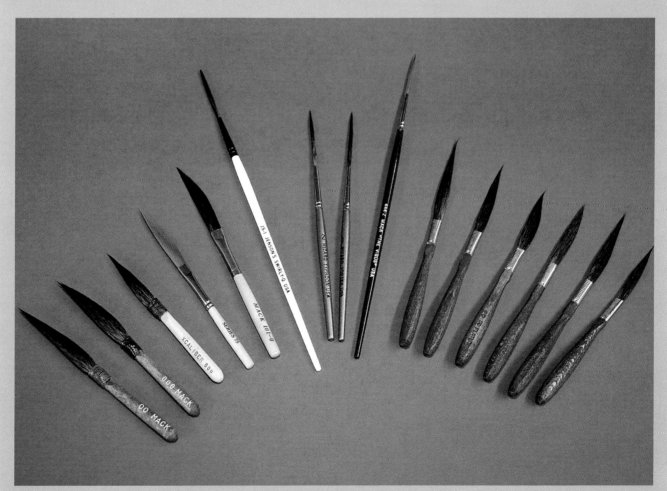

From the industry-standard #10 Mack pinstriping brush made from pure squirrel hair, to a whole series of newer long-line stripers like the Mack-Lite, Mack-Belly and Fast-Lite, the Andrew Mack Brush Company offers something for nearly anyone. In addition to these "striping brushes" the company offers a full range of artist's brushes made from both natural and synthetic fibers.

With Yankee ingenuity, Andrew designed and built a better striping brush, one that held more paint and maintained it's shape better than the cheap brushes his crew was using at the time.

The improved brush came to be known as the Mack Striping Pencil, and demand for the Pencil grew until Andrew was forced to leave the wagon factory and start a small factory of his own. Under Andrew's direction, the Mack Brush Company continued to prosper right through the depression and into the 1940s. When Andrew passed away in 1946, his son Glenwood took over the job of designing brushes and running the operation. By this time, Mack was producing brushes not just pinstripers, but for sign painters and artists of all stripes.

The next big change came in 1960 when Mike Fast, a friend of the Mack family, purchased the business. Today, his son, Chris is the young man you're likely to meet at the Andrew Mack booth at any number of events.

If Andrew came back to life, he'd be pleased to find that nearly all Mack brushes are still made by hand in the US of A. And though some of the brushes use synthetic bristles, many are made of the same high-quality squirrel hair (often called camel hair) used in the original brushes manufactured in the late 1800s.

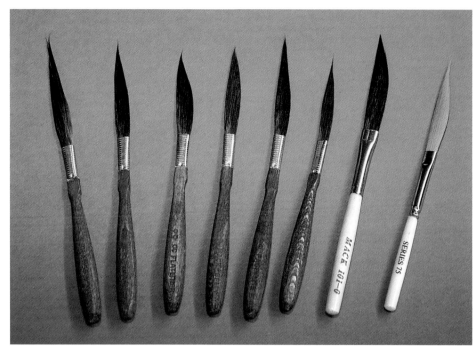

The long-line stripers from Mack. Most use squirrel hair, though a few mix synthetic with natural, and one is totally synthetic, the Series 75. The Glawson Mack (far left) uses long squirrel hair to create a brush that's good for long thin lines. The DC Flatliner is patterned after the original, #10 Mack.

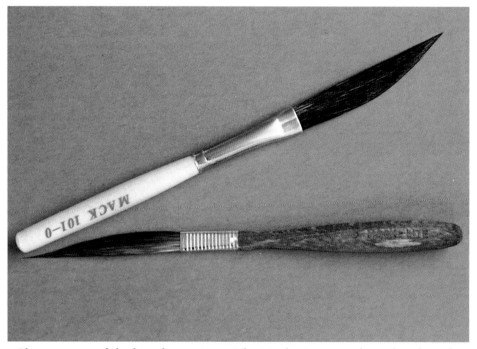

Close up, two of the long-line stripers. The Mack-Lite uses a brass ferrule and has less belly, which means it's better for design work and not as good at long lines (as it doesn't hold as much paint). The 101 series, (similar to a brush by Grumbacher) is designed as a very durable brush that will hold a lot of paint.

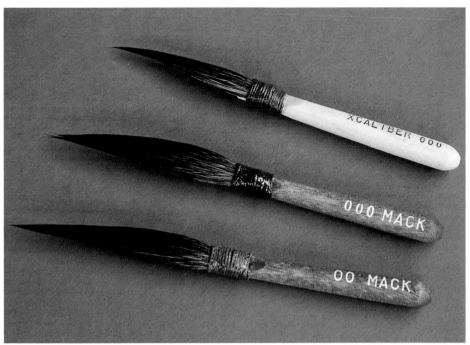

What might be called the brush that built a company, the premium #10 (a pinstripe brush made from pure blue squirrel hair), is flanked by the Series 20 on the bottom (100% squirrel, designed as a general touch-up brush), and the newer Xcaliber, (shorter natural bristles, works very well for intricate design).

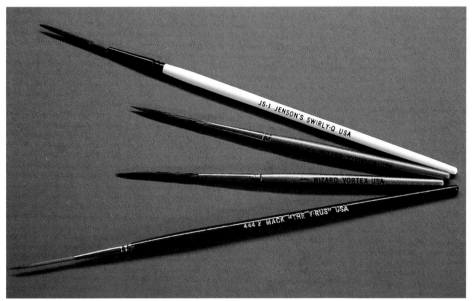

Scroll brushes by Mack, many designed by artists. On the bottom, the 444 (designed with help from Dave Jeffrey), made from synthetic bristles and well suited to script or scroll work. The Swirly Q (designed with help from Gary Jenson) is another script/scroll brush made of 50-50 natural and synthetic bristles. In the center are two Steve Wizard brushes. The Vortex, made from blue squirrel hair, comes to a point and is ideal for script work. The Typhoon is similar, though Steve designed it to be just a little faster.

Hardly an old company stuck in its ways, the Mack Company is forever refining their brushes, testing new synthetic materials and developing new brushes, often designed by artists for artists. A good example of this are the two scroll-striping brushes designed with help from Steve "Wizard" Chaszeyka, the Vortex and the Typhoon.

Whether you use synthetic or natural-fiber brushes is a matter of the paint you use and personal preference. Squirrel hair, often referred to under names like blue squirrel or Kazan, is the single most popular choice for natural fiber pinstriping brushes. Synthetic fibers stand up better to the harsh cleaners used with urethane paints. They are not as soft as natural bristles, however, which means they do not carry as much paint.

As high quality squirrel hair becomes harder and harder to find, and more and more painters switch to urethane and water-based paints, more of the brushes are manufactured from synthetic fibers, or a blend of synthetic and natural bristles.

No matter the material, it seems there will always be pinstriping brushes, assembled by hand, so true artists can pull a stripe all the way down the side of a Model A, without having to stop and go back to the palette for more paint.

Q&A, "Chris" Fast

Mike Fast, longtime friend of the Andrew Mack family, bought the company in 1960. Today, Mike is in the midst of a transition that will leave his son, Jonathan "Chris" Fast as owner of one of the oldest brush companies in the world. For the inside scoop on pinstriping brushes, from which one to use to the difference between natural and synthetic, we asked Chris Fast to set us straight.

Chris, do people make mistakes in the brush they use?

I don't know if you'd call them mistakes. Sometimes they call and say they're using a particular brush for something different than we designed it for. Other times, depending on the kind of work they do, we urge them to try a new brush. I always tell them, "you might not like it today, but you will grow into it. Sometimes they are so comfy with the number 10 brush that they do everything with it, and maybe they do it that way because they just don't want to stop and pick up another brush."

Where do the best natural bristles come from?

Northern China and northern Asia are two main locations. The region needs to be quite cold for the squirrel to develop a long-haired tail. Our resources for blue squirrel hair have been good for quite a few years. For brown hair (Kazan) and grey hair (Talahoutky) the materials are a little harder to come by.

Tell us the difference between natural and synthetic bristles, and are more and more of the brushes being made with synthetics?

We use more natural material than we do synthetic, but the synthetic gets better and better. We have a new synthetic black squirrel that's very good.

In spite of what people think, natural bristles work great with urethane, the problem is the dry time is quick and the materials used to get the

paint out of the brushes is more abrasive than what is used on a lettering enamel.

What are the trends in terms of brush design?

Like I said, the synthetic material continues to get better and better. The Mack brush company is always looking for new ideas. We often do a prototype of a new brush and send samples out for people to try. If we get bad reports then we don't manufacture that brush. We go to a lot of events, not just to sell brushes but to get ideas and to get feedback from the artists who are using our brushes.

What do you recommend in terms of care and feeding of a brush?

We recommend cleaning the brush with a reducer, turpentine or the recommended cleaner for the particular paint being used. Once the brush is clean we like to see pinstripers use a brush preservative like Neatsfoot oil, Xcaliber brush preservative, or Wall Dog brush preservative. We do not recommend motor oil, because it contains so many additives.

Chapter Seven

The Wizard

Steve Chaszeyka

To begin this project, a 12 x 18 inch aluminum panel is coated with green metallic urethane, clearcoated and then scuffed. Next, the lines are laid down, first with white Stabilo pencil, which gives me some sort of parameters and guidelines for my design.

Often I am asked where these designs come from. Over the years you watch others

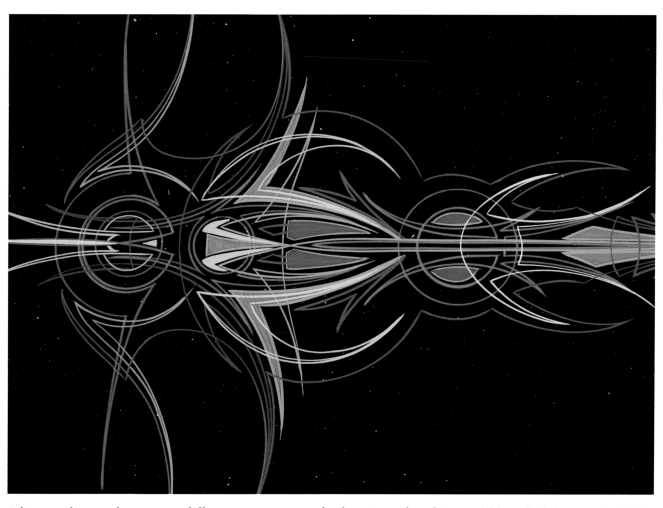

This complex panel uses many different components and colors. Even though it would be called dagger-style, I like to utilize circles in the art. I always say, 'they give your eye someplace to go.'

All copy and captions by The Wizard.

develop designs that you like. With time your own style emerges from watching these inspiring stripers.

Guy Shively, a local artist, first introduced me to pinstriping. More recently, however, Jim Norris, Curt Johnson and Tom Van Nortwick have shown me new directions for pinstriping art, which inspired to do the very involved and colorful work you see here.

I take an old compass, dip the lead-holder into the H of K orange, wipe excess paint off with a rag, and begin a series of random circle shapes using the taped out areas as a base for the point of the compass.

TECH TIP
When using the compass, the thickness of the line is also determined by turning the dial on the lead-holder. You can make the line thicker or thinner by making the opening correspondingly larger or smaller.

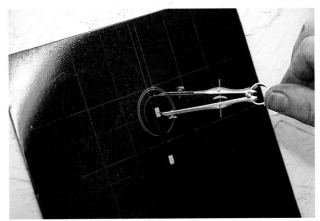

Notice that you have to "lead" this compass by angling the tip so the paint can roll off the tip. Viscosity will vary according to how you thin the paint and this will affect the thickness of the line.

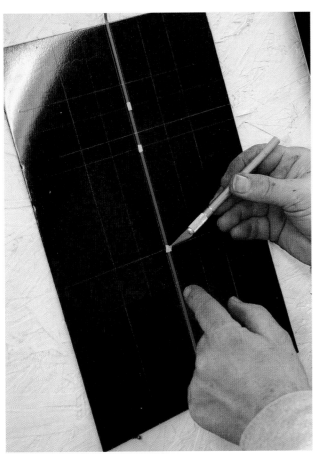

Here, I'm placing blue fineline tape down the exact center of the panel, then reinforcing three or four places with additional thicknesses of masking tape. This gives me a "base" for my first trick.

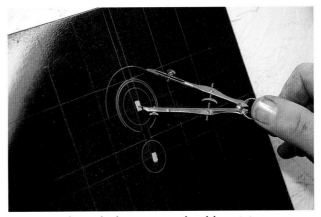

Lines made with the compass should anticipate your design. Leave variations in the starting and ending points, making sure that these are always on a horizontal plane. You'll see this in the next step.

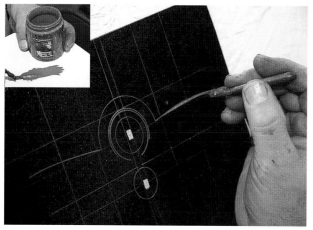

Next, I pull two horizontally curved lines outward from the bottom of the outside circle, you can see where this is going.

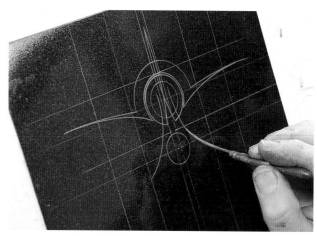

Move out with downward-moving graceful strokes…

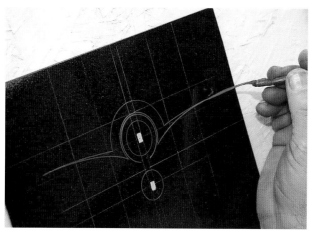

Connect to next inside circle and take a look – determine what your next move is.

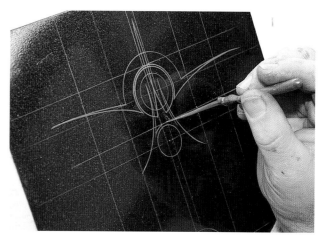

…incorporating the circle by acknowledging it with a framework, or circular line, and darts that point to it.

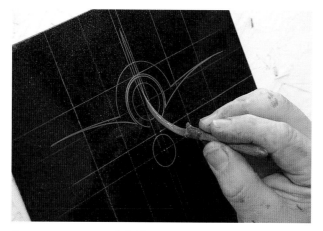

I connect a vertical "C" curve, crossing it in the center of the design, to the bottom of the next inside circle, closing it off. This begins my first "cluster" or point of interest.

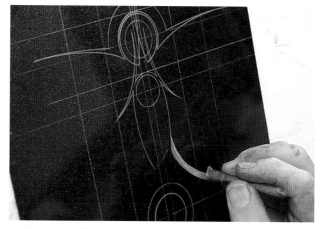

Moving on down, stop and anticipate how you will address the next series of circles.

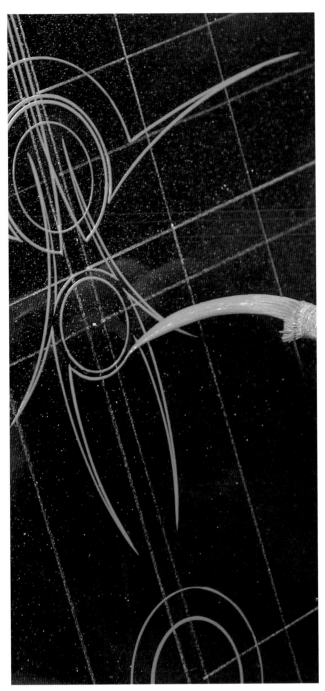

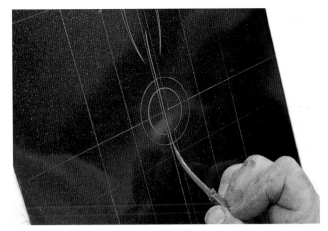

Obviously, to me the most effective way to get long and thin is to pull a long teardrop shape through the bottom circle...

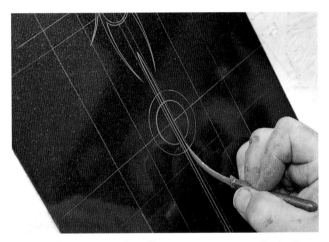

...stretching out and pulling your eye towards the bottom very quickly.

Rather than running into the next circle, I decided to close off the top cluster and isolate it with a "C" curve around the bottom of the circle, this makes a really nice center of interest to work off of later. I also like to make the design a little thinner as it goes towards the bottom of the page, so now I am thinking about some longer, thinner shapes toward the bottom.

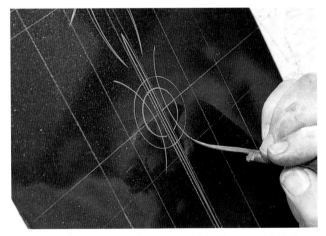

Moving outward, pulling a couple of outward facing "C" curves, the first two that appear in the design.

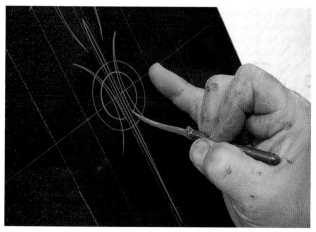

Not wanting to head out vertically just yet, I continue downward and connect into the inner circle. Very nice!

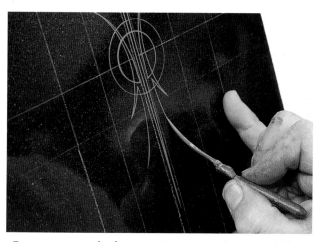

Connecting to the bottom, I move on down and finish this segment, making sure to connect all the lines to something.

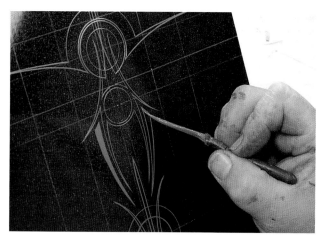

Some fill seems to give weight to areas where you want main points of interest, so lets insert a couple here and there.

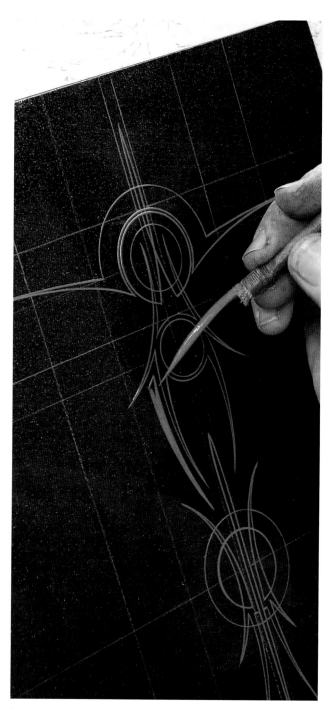

The more intricate your designs become, the more care you need to exercise with your brush handling skills. A drop now would force you to wipe off a major percentage of the work, and repairs are really difficult…so be careful! Notice how the grip used on the brush here is backwards, filling from the bottom to the top, you have to let the design dictate the direction of the brush movement - not the other way around.

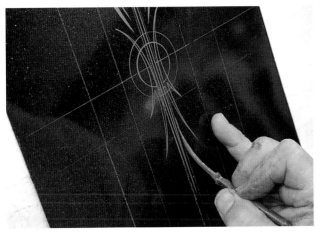

Let's add some weight to the bottom…

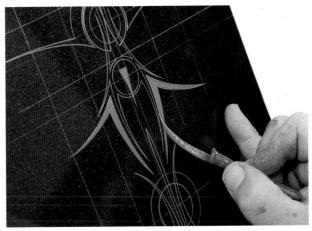

Changing colors to a medium blue, let's outline these heavy areas…

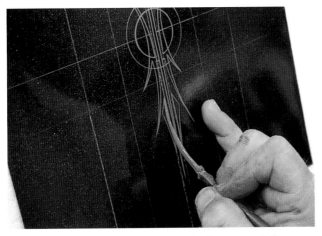

…filling carefully, using the little finger to slide along when you can…

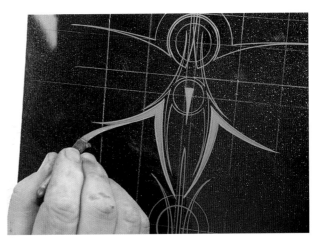

…carefully finishing the shape by connecting with a point…

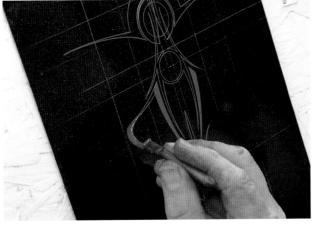

…a couple of outward additional fills places more emphasis on the top of the design.

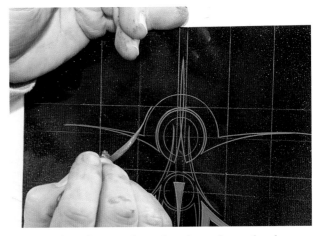

…keep distributing this color throughout the shape to continue eye-flow..

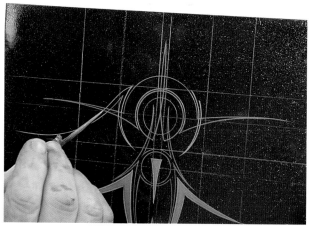

I want to use this blue to complement the orange, it is a color that opposes orange on the color wheel, adding interest.

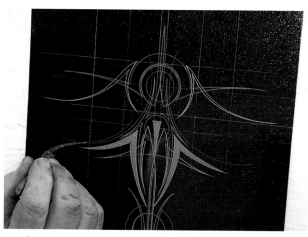

...this color is also enhancing your base design...

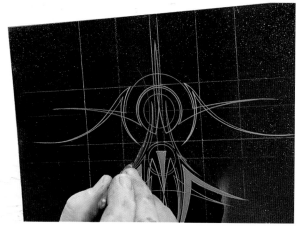

Now a color change to red, with the same brush...

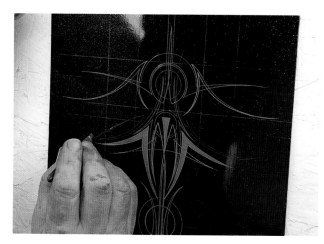

...giving support to your existing framework, as well as adding a LITTLE interest here and there.

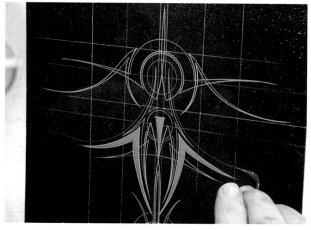

...slice and dice your way randomly through the design, cutting it, dividing it, keeping in mind that...

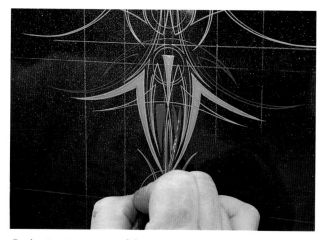

Let's give it some red hot spots.

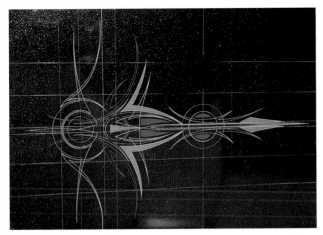

Stop, ponder, study, anticipate your next moves, the next color combos.

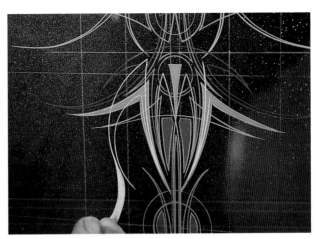

Sparingly here, this color carries as much weight to the eye as all the blue because of its stark contrast...

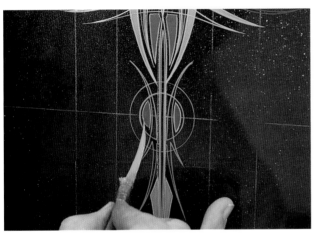

Shock value is in order, green on red!- DO THIS SPARINGLY.

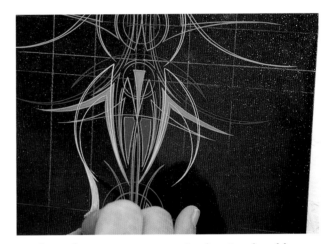

...this is how you correct a mistake, simply add another line to both sides, one on the inside, and one on the outside, making both equal.

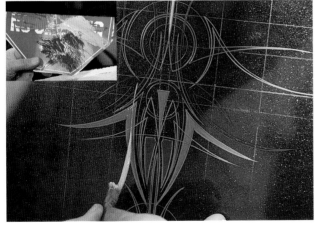

Adding a drop of yellow to the green lightens it up. Let's shock this design with some hot lines!

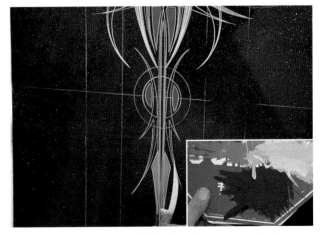

Lets just add a little of this bright green to the bottom.

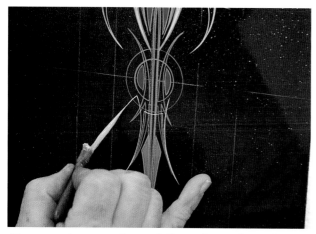

Down and outward, carefully studying the arch so that you can match it on the other side.

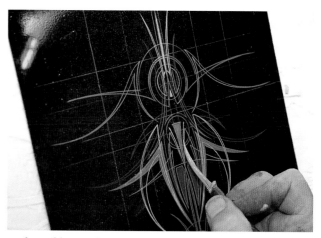

A bit of heavy lavender, … why not.

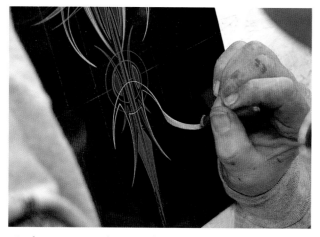

And arc it over the top, this is one of the most daring and difficult strokes, it could trash the whole design, - NOT FOR BEGINNERS!

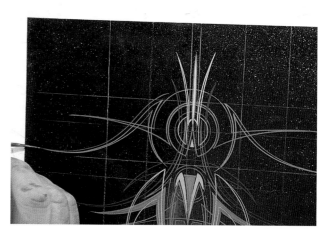

Dark purple won't show much, but when you are studying this design, it sneaks up on you and adds interest…

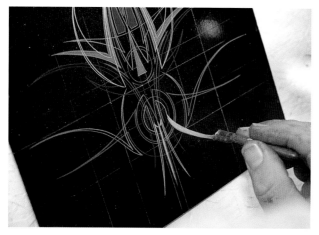

Flip the panel upside down, change to violet and build some interest in the top of the design.

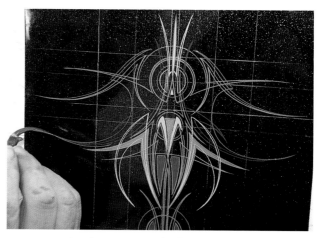

…giving the design just a little more flash.

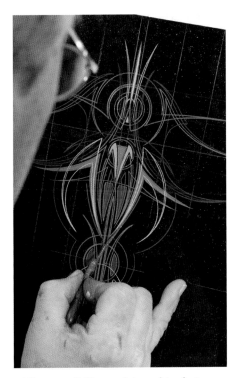

After carefully studying this design, and wanting to give it all I had, I thought that just a little more orange was necessary on the bottom, since it had none.

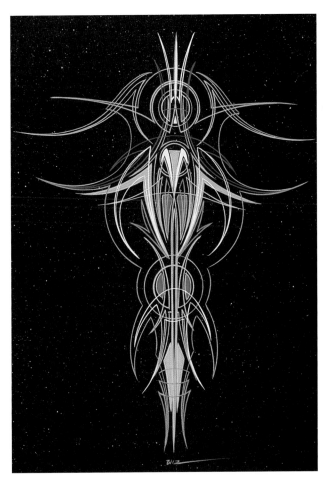

In the final analysis, I would give this design a fairly high grade. You always are very critical with your own work, and my wife, Carol, hasn't critiqued it yet. She is the final judge. Her comments drive me to pursue different directions, and tighter, thinner lines.

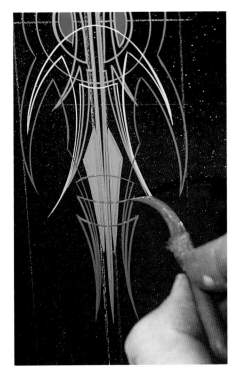

A nice flourish of hot red brings your eye towards the bottom and lets the design sit on a strong base.

IN THE END

Work like this can bring tremendous rewards - self satisfaction notwithstanding. The financial side of pinstriping seems to range from the ridiculous to the sublime. I would probable like to charge about $250 for this piece on a bike or a car. Could I get it? Now, that's the question!

I hope you have learned some moves, as well as some color theory. I like to pallet "dirty", mixing color on top of color right on the pallet. This warms or cools the colors correspondingly, giving you endless possibilities. I kept it to a minimum on this piece, trying to keep the colors pure for the photos, but try it on your stuff! It really makes for some interesting combinations. Note, when doing it for customers, keep it to a minimum so that you don't have to rack your brain in case of a repair!... 'till next time.
The Wiz

The Wizard, Part Two

Scrolling

Now for something totally different. Whereas many pinstripe designs are geometric and often use straight lines and angular intersections, (often called dagger style) the scrolling work flows from one arch to another. From curved dashes of color to whimsical swirls that nearly run off the edge of the panel. The splashes of color change shape, often starting as a wide line and ending narrow. To do this I start with heavy pressure on the brush and then let up as I change the width of the line.

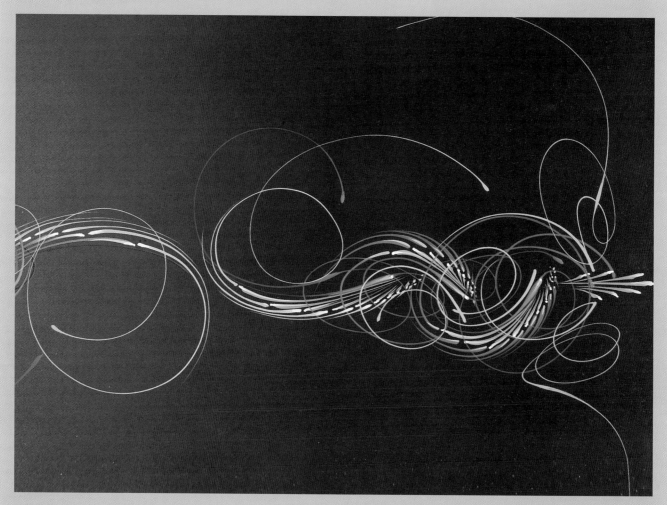

The panel seen here is a good example of scroll-style pinstriping. This can only be called way different than the more common dagger-style. Looking at all the color, the swirls and arches and dashes of color, is reminiscent of a peacock's tail feathers.

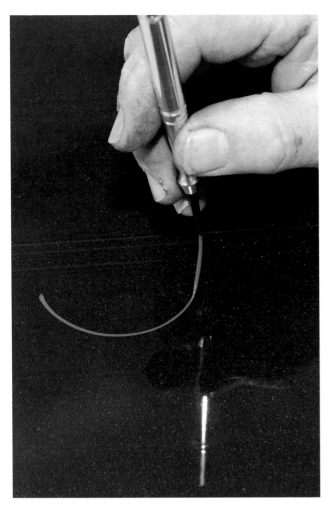

I start out using a Lazer lines brush...

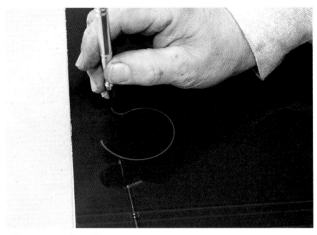

First a circle of paint....

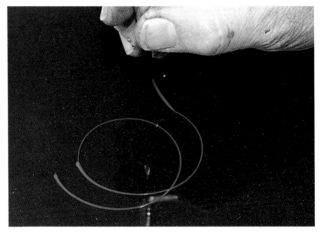

...slowly, concentrate on keeping our hand out of the paint...

...oops, ran out of paint, had to reconnect leaving a fat spot. I keep circling and cut back into the second circle and loop outward. Now I press downward on the brush, giving me a thick spot, then I swing down...

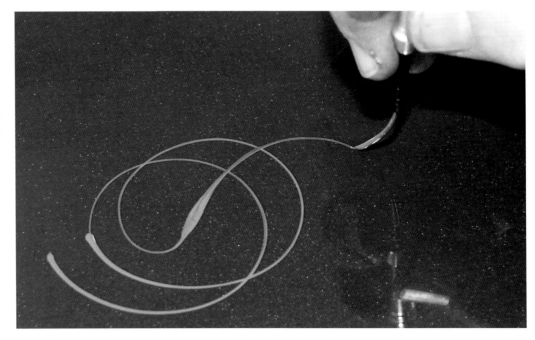

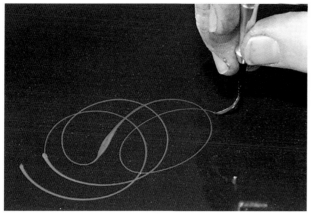

I drop down and create a couple more loops that run in the other direction.

What I call "dirty palleting" requires that you add a drop of yellow to the orange, and lighten up the insides of the fat spots only, stroking downward through each one.

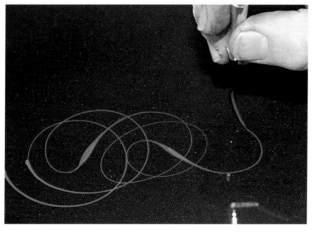

Next I do an inside loop, then press downward for another fat spot, then pull the brush back out and down...

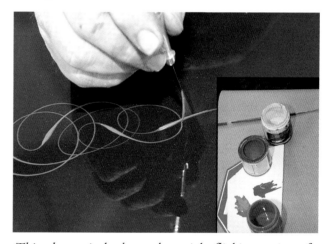

This photo nicely shows the quick, flicking action of this stoke. Keeping your aim accurate, it will end INSIDE the design and not create another line.

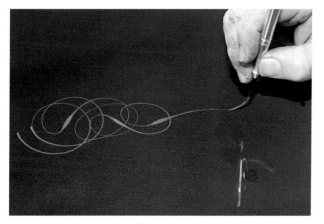

...and finally, tail it off with a thin line Whew! Those are a lot of curves and the most difficult part of the design. It forms the basis of the layout, and requires lots of practice.

Palleting techniques like these add interest to your design by mixing complementary colors together, lightening or darkening your mix.

TECH TIP

When changing colors completely (as opposed to "dirty palleting") be sure to have plenty of mineral spirits around and paper towels handy to completely clean your brush, otherwise you will contaminate your design with a muddy color, or the last color you used could leach out of your brush and show up unexpectedly.

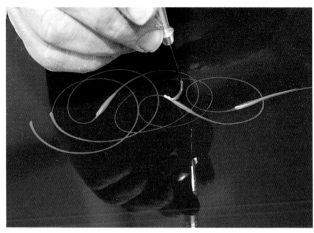

1. Adding just a drop of yellow smacks this fat orange spot to life and gives it that final flash!

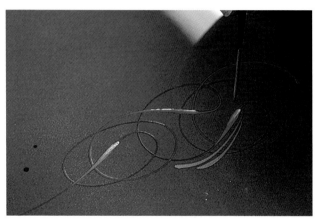

2. I turn the design upside down and pull the next color towards me. In this case green subtly fills in the "gaps" in our scroll with a triangulation of longer-to-shorter descending teardrop shapes...

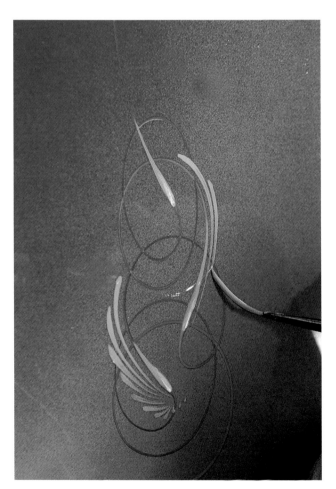

4. Here I continue to use the green to fill in the gap areas – you do have to be careful not to overdo them!

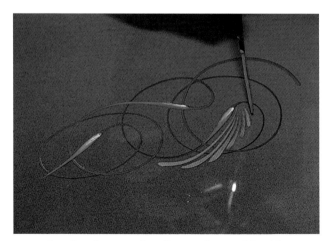

3. ...that bend inward to form a beautiful addition. I couple these green shapes with a series of small dots which get smaller and smaller.

Q&A, The Wizard

Steve, How did you become a pinstripe and air-brush artist?

I was inspired coming out of the Navy. I always liked to draw and paint, but didn't see any way to make any money painting. Guy Shively was a local pinstriper back in those days, and I watched him a lot. I figured if he can do it, maybe I can too. So I bought some brushes and learned by doing. I learned airbrushing the same way. A friend in the Navy showed me his airbrush, but I had to learn everything by myself. Now it's easier because there are books, and tapes, (including my own) and seminars.

Are there other artists who continue to inspire?

I really like the work of Russ Mowry, and Charlie Bussard was a huge amount of help when I started to do the scroll work.

Where do you get your ideas?

I look at old literature from the1800s, things like the scroll on the inside of a book cover, the stripes on old armor. At the turn of the century they used some nice packaging and lettering styles.

I really like some of those old lettering styles. Sometimes I go to a weapons museum to see the scrolling and engraving they did on the old guns.

How about color, the panels seen here use bright color combinations, how do you decide which color to use next to another?

I just look into nature, rocks and flowers. Rocks have very nice, subtle tones that are really pretty. And of course flowers give you great color combinations. Just look out into your back yard for ideas. Carol and I collect rocks.

What do you like for brushes, what are those metal handled brushes you used for some of the work seen here?

Those are Lazer Liners, they're new to me. I like the synthetic brushes for slow, intricate work, like art pieces. At a show though, I can get more done faster with a natural bristle brush. I like the Mack series 10, It hangs onto more paint, with synthetic you have to reload the brush all the time.

How about paint, which paint do you like and why?

I am habitually a One-Shot guy. But I've noticed a drop in pigmentation lately. I've been trying Ronan for a lot of my striping at the shows, when I want oil-based paint. At the shows you don't have time to double coat. You have to work fast. I'm looking for heavy pigmentation.

When I'm going to clearcoat the parts, I use H of K, but I've also been trying Xotic paint lately. They're all good paints, but I'm picky.

Any advice for stripers who are starting out or trying to get better?

You really have to look at the old-fashioned way of learning, the school of hard knocks. There is no replacement for practice and really knowing what you're doing. Some new pinstripers try so hard to look like the old-skool guys, they should spend that time and effort working on their painting skills. You have to be able to get into the Zen of it, so you can stripe in bad light with a ton of distractions, and still do good work.

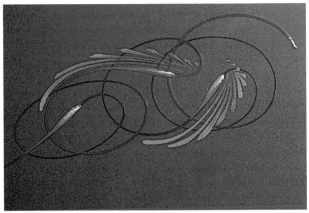

Looking at the final photos of this design will show you just where I am going with these, it may be helpful to peek ahead at this point and study the final design.

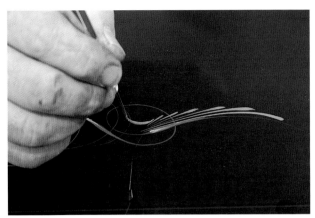

Each splash of green is smaller than the one before...

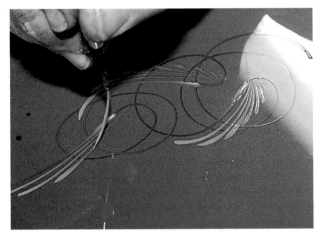

Now I use the green again...

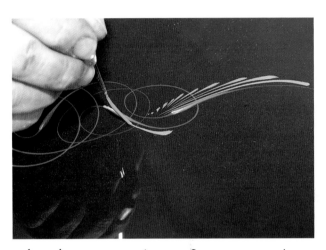

...here the pattern continues as I start a new series.

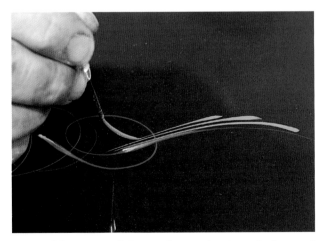

...to add a series of shapes that evolve into dashes and dots.

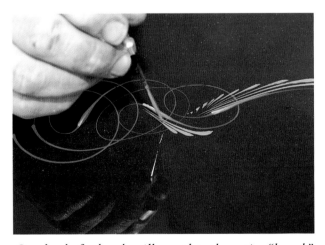

One load of a brush will complete the entire "bunch" of these...

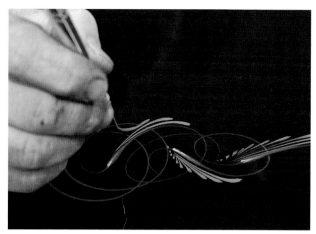

...until you have completed all that the design requires.

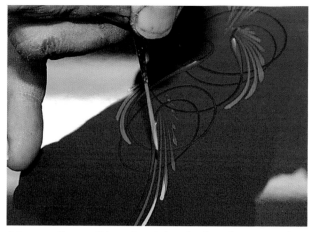

Now, palleting "dirty," I dab a little yellow into the green to lighten it up, and move on to the ends of these green lines...

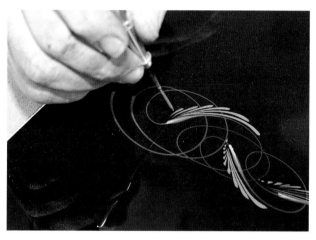

Learning to keep the amount and weight of these green shapes consistent requires practice.

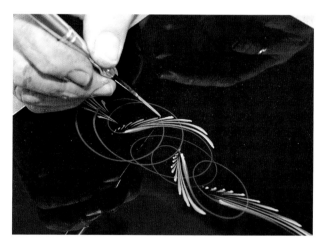

...just hitting the tip and sweeping part way, getting progressively smaller as your lines are smaller.

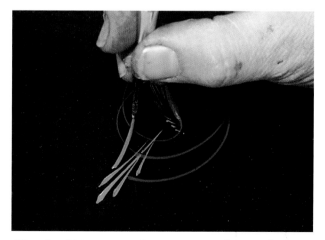

Here I add just a couple on top to indicate which end is which.

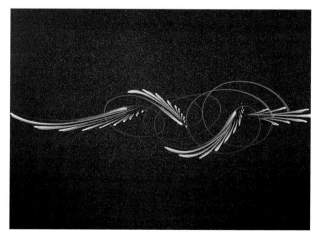

Notice that we've given them the same treatment as the fat lines in the orange color.

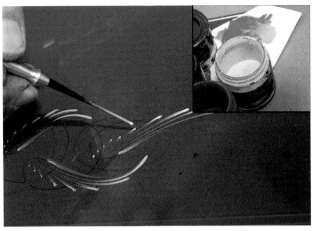

Now, the coupe de grace! (or however you spell that) – dab the yellow onto just the tips of the lines all the way down to the dots – and look…

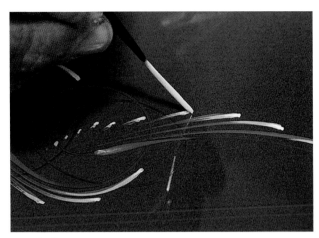

Don't forget …

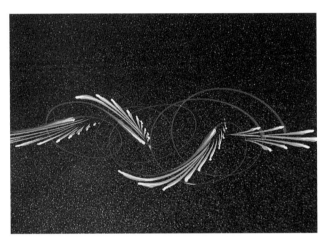

…at the excitement you've created!

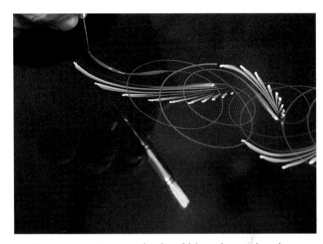

…I'm moving into a shade of blue that is hard to see, but adds dimension…

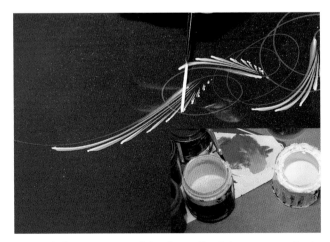

Now, let's just go to white for a final hot spot – that's it!

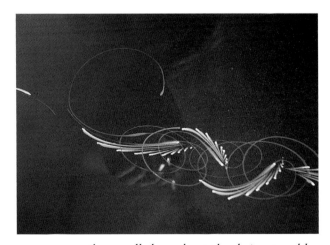

…sweep another scroll throughout the design to add a flourish and to swing it outward even more.

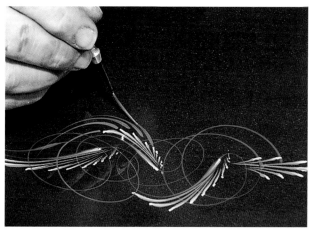

This one comes off the end of the lowest and bottom-most green line and swirls around to exaggerate the direction of the design with additional swirls.

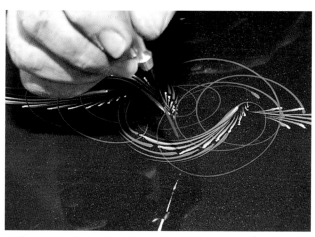

This step, although subtle in color, adds much interest.

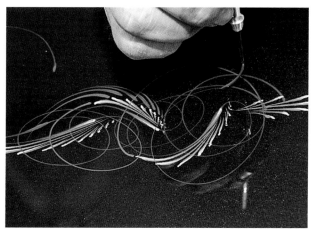

I have to be careful here. This is a crucial step, and can completely ruin the whole thing.

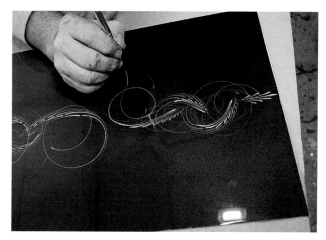

Careful! Your hand wants to drag along – you might have to lift off the panel altogether.

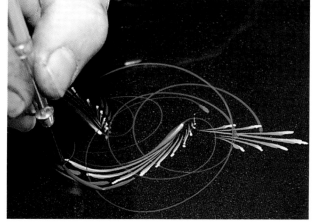

Follow the rest of the green lines with opposing blue lines pulled away from each green line, descending, correspondingly smaller, diminishing to dots.

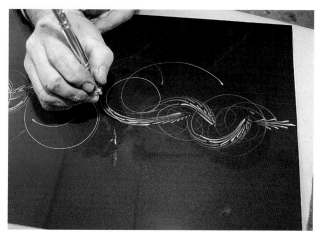

I'm resting my wrist on my other hand here for support.

Final Tech Tip

These designs were completed in less than 30 minutes – and looking at them, they aren't exactly alike, or are they? That's the beauty of scroll style, it's a different kind of balance. It has an interpretive stance, rather than a symmetrical posture, unlike the dagger style. But, don't kid yourself – it's every bit as hard to master!

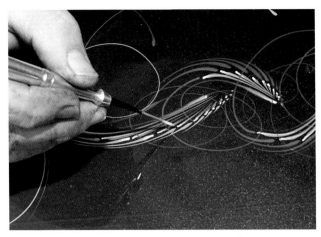

Here, I'm adding a little dab of white, thrown in to highlight the blue action…

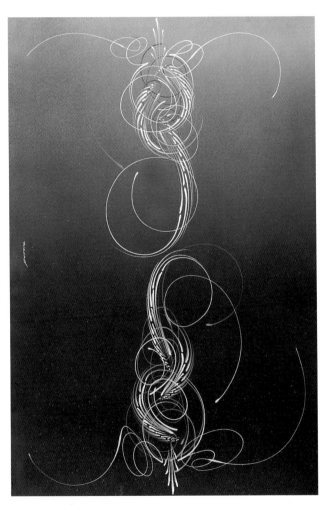

The finished panel. Looking at this design is just plain fun, don't you agree?

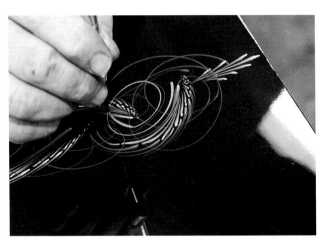

Which gives this design a little subtle "fill", then…

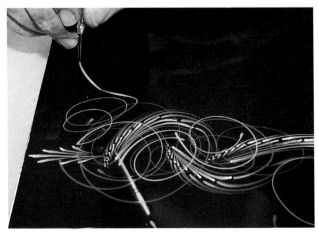

…I whip the thing outward, scrolling it into a long lean tail, filling the outer limits. Add a little whitened blue to fat spots here too.

101

Chapter Eight

Lenni Schwartz

Some People Make it Look Easy

Like a lot of pinstripers, Lenni has very little formal training. He learned most of what he's learned "on the street." Though he started out lettering trucks and painting signs, today he's best known for his airbrush and pinstripe work, most of it done on custom motorcycles. Working out of a small shop, Lenni does paint and only paint, from complete paint jobs to pinstriping and airbrush work like that seen here. What Lenni doesn't do much of is the heavy bodywork

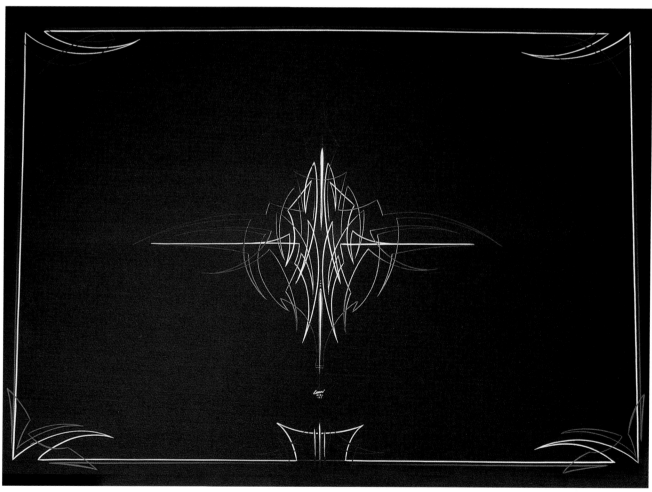

Simple and somehow elegant, this panel is definitely old-skool-cool.

Captions by Lenni

and clearcoating, preferring to leave that for other body shops and painters with big spray booths.

In this case he started on a fairly large, flat black panel, and laid out a simple and clean old-skool design done with only two colors, roman red and white. Both of these colors are from the House of Kolor urethane striping paints, numbers 03 and 02.

Lenni starts with two centerlines, explaining as he does, "I used to grid out the panel so I could position everything in exactly the same position from right to left, and top to bottom. I find now though that I just don't need the aids anymore. I can place things evenly without the grid. With cars, I just run a piece of tape down the center of the hood before I start to do any of the pinstripes."

Before any paint is applied to the panel, Lenni wipes it off with a rag, dampened with Windex. This is Lenni's way of making sure the panel is clean and that the static electricity is eliminated. "Some people use that static spray," explains Lenni, "but the damp rag works fine for me."

When it comes to brushes, Lenni sticks with simple and inexpensive 00 sized brushes from Mack. When he needs something finer, he just cuts half the hair out of a 00 to produce his own 0000. Once he starts pinstriping, the entire process goes pretty fast. Lenni does the whole painting on-the-fly, without the benefit of a photo or sketch. Like a talented guitarist, Lenni's music just seems to flow out the end of his brush. Even the neat borderlines are done in a casual, 'why don't we try this' fashion. And of course the double lines, with embellishments, look great and add to the panel without taking anything away from the main design.

As is often the case, the photos tell the best story. The story of the magic that comes off the end of a certain Mack brush. The one that started as a 0000 before some guy named Lenni cut it down to about half that size.

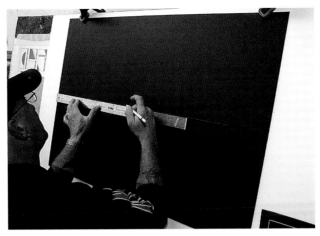

Before doing anything, I make sure the surface is clean and grease free.

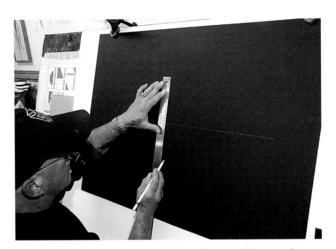

Then I draw in a horizontal and vertical centerline. These help me keep the design centered and symmetrical.

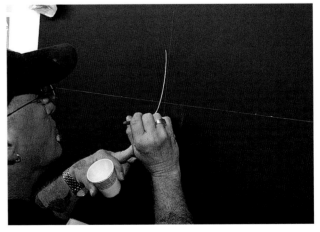

I just start out on one side...

103

...and then duplicate that first line with another on the other side.

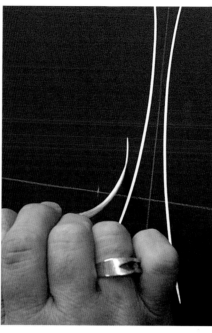

I treat these lines as building blocks.

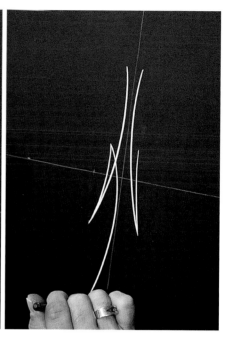

I do one side...

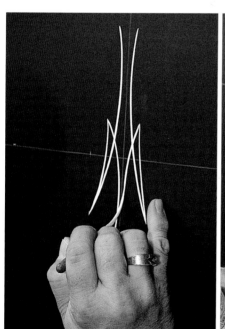

...and then do the other.

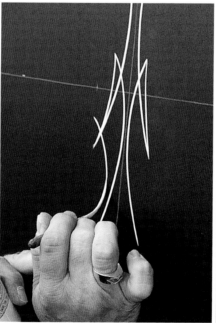

Now I can start to branch out both vertically and horizontally.

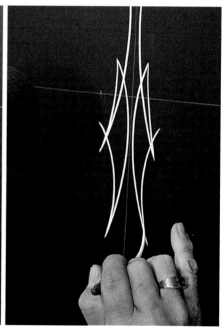

I do have to make sure these lines will come together at the bottom.

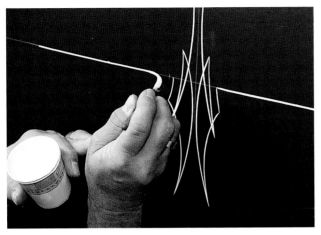

Here I'm adding horizontal lines to give the design more breadth.

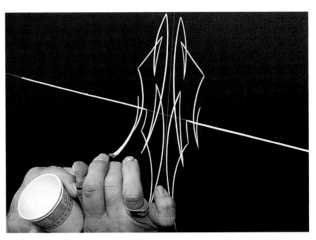

... I don't consciously think about the design.

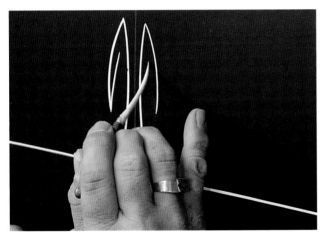

As I continue to add lines I'm trying to make this a balanced and more interesting design.

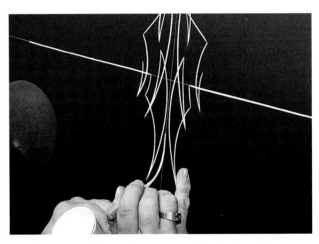

At this point I have the essence of a design. Time to add a little something extra, like a teardrop.

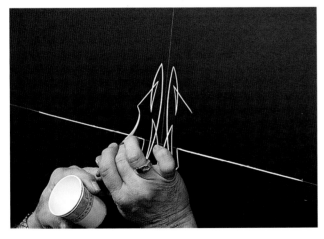

A lot of this just flows for me...

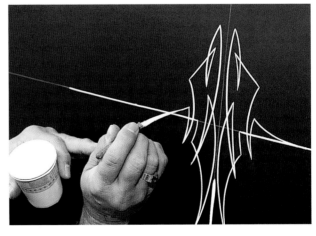

Next I move the design out to the side again.

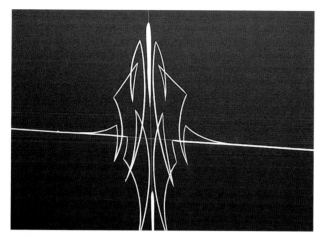

After I'm satisfied with one color...

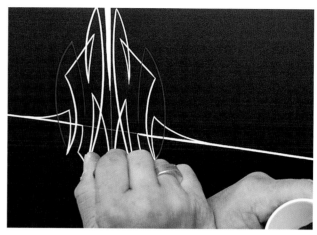

When in doubt I keep things simple.

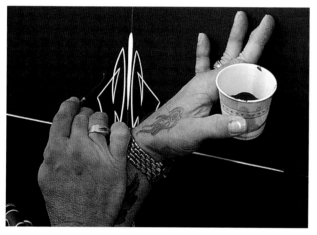

...it's time to add another. Roman red in this case.

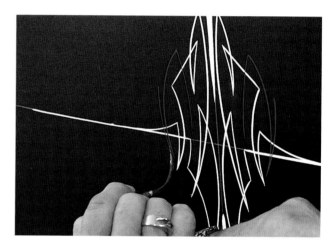

I always try to keep the flow of lines even...

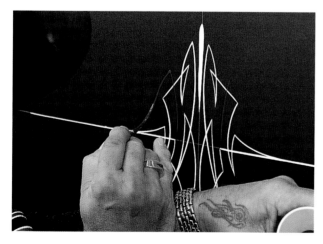

You need to pick a starting point, I'm careful here not to crowd anything.

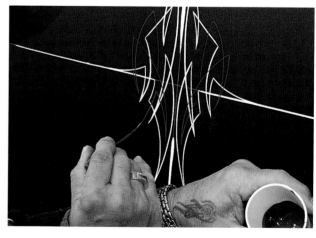

...from one side to the other.

Q&A, Lenni Schwartz

Lenni, tell us a little about how you became a pinstriper and painter.

In the beginning I was just lettering. In fact, I was always scared of striping, I didn't think I'd ever do it. But finally I decided to give it a try and it worked. It's interesting how you can be afraid of the brush. The first stripe job I did was on a '68 Chevelle. The car was a cranberry, or brandy wine, but I did the stripes in red and blue. Looking back, I guess I would have chosen different colors. And my early stripes were all oversized and too fat.

How did you get good at pinstriping?

I spent a lot of time looking around at what other stripers were doing. And I practiced, practiced and practiced. I knew what I wanted, the kinds of designs I wanted to do. I knew I wanted thin line work, it just took me a while to get there. I've always been known for my thin lines.

Who inspired you, who do you look up to?

Early on it was Joe Murel, I don't know if he's still striping, this was in California where I lived until I was 21. Von Dutch and Ed Roth were both influences. And Craig Judd, he has really fine lines.

Where do you get ideas?

In my own mind. It's just a matter of whatever

comes out of the brush. The brush does all the work, I just hold it.

What do you like for brushes?

I usually use a Mack 00, and then I cut them up. Some I cut in half so that's a 0000, but when you start cutting them pretty small they don't last.

How about paint, what do you prefer for striping paint?

Well, it depends on what I'm painting. If it's going to be cleared I use the House of Kolor striping urethanes. When I stripe cars on top of the paint, and I know it's not going to be cleared, I use H of K with the catalyst in the paint. I still use One-Shot for signs and for truck lettering. You can catalyze it, but it's pretty durable just straight up without the catalyst.

If someone asked you 'how do I get better as a striper?' what's your advice?

The more you do, the better you get, you learn to use both sides of your brain. You push yourself. I always say, 'You buy the tools, but God gives you the talent.' I think it's a matter of developing the talent you're born with. We're only really as good as we want to be. With striping you can always get better, so it always keeps you striving to improve and be a better artist.

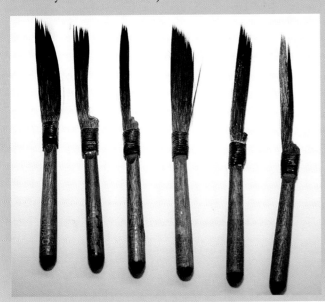

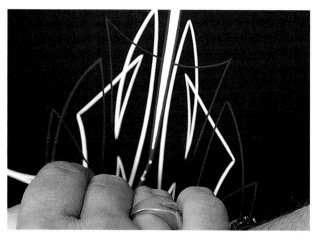

I think you get a lot more impact when you outline the white teardrop with red.

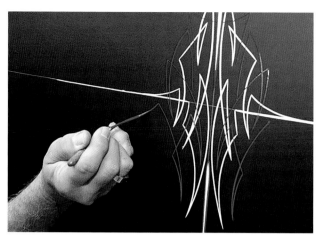

To get nice, thin, consistent lines, the paint has to flow just right, you have to keep the noodle wet enough.

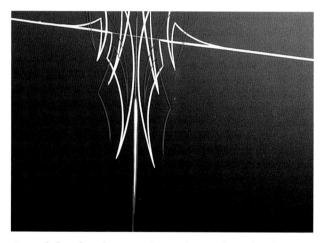

I work hard to keep my lines thin. I love the thin stuff...

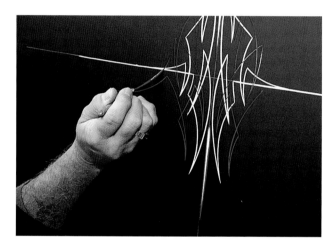

But if it's too wet it runs, and if it's too dry you get a jagged line.

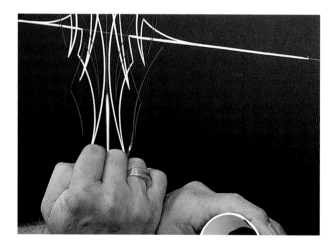

...and to keep them thin I often cut the brushes to get exactly the size I want. Some people use a stick for support, I just use the other hand.

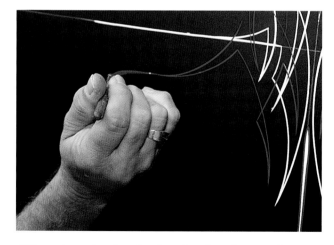

When the paint is mixed and paletted correctly it just flows off the brush like magic.

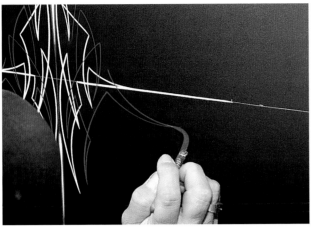

You have to be careful to follow through with the rights and lefts...

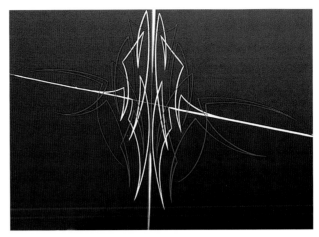

A progress shot, notice how the teardrops give the design some meat, and the glow that comes from having the colors so close together.

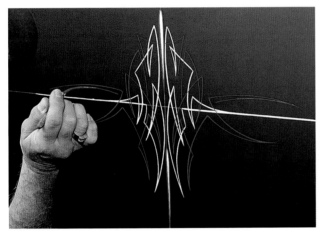

...so both sides are symmetrical.

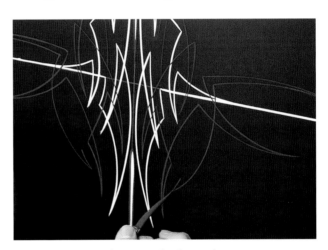

I'm still just working on the basic design...

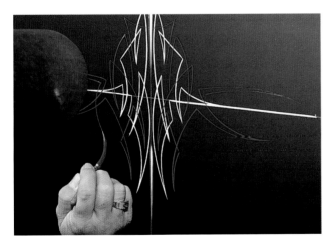

I try to keep everything balanced, you can always add color later.

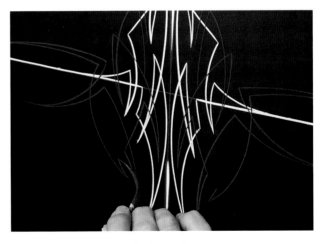

Adding more red to the basic layout.

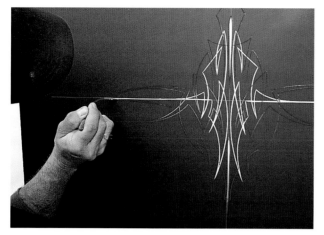

I chose to do the white first...

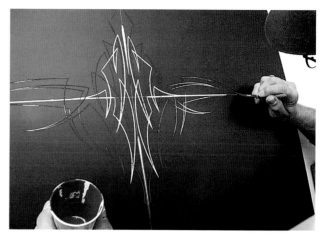

I can add as much red as I want here, but I'm careful that I don't...

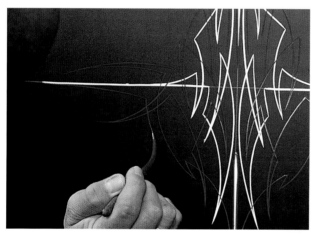

...and consider this to be a white design...

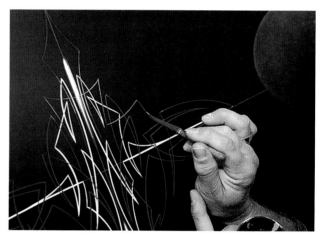

...loose the heart of the design.

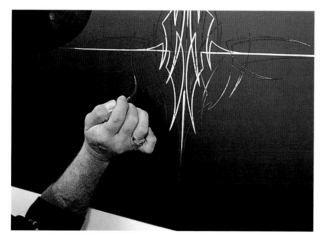

The red is here mostly to make the white pop.

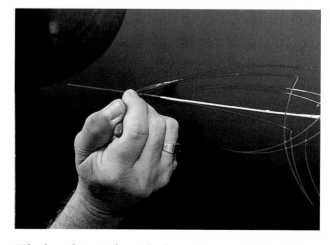

The last thing I do with the red is to pull the design to the sides just a little more.

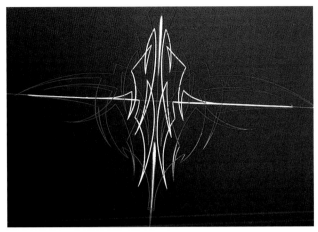

The horizontal elements in red are done, which finishes the design.

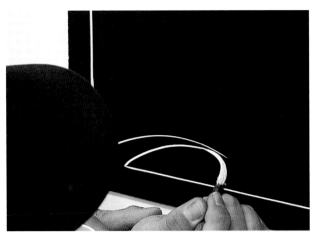

...which add a lot.

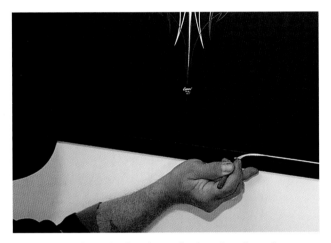

All that's left is the border, which I decide to keep pretty simple.

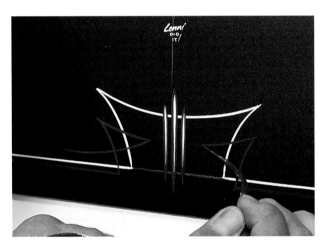

The border is done in two colors, but even with the swoops...

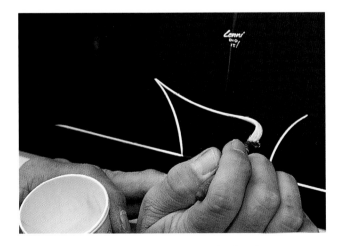

I do add some embellishments to the border...

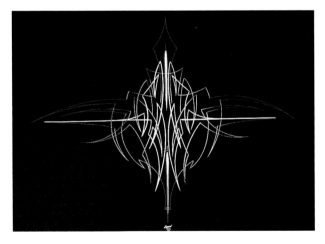

...the border isn't so busy that it takes away from the main design.

Tips & Tech from Jon Kosmoski

Advice from Mr. Kustom Paint

Jon Kosmoski isn't a pinstriper, at least not on a day-to-day basis. Yet, we've included him here because first, he's a pretty good striper in his own right, and second, he's the person who developed the House of Kolor urethane striping enamel, the striping paint that at least half the pinstripers in the world use on a regular basis. The project seen here is a demo half-tank already painted black. The design is just something Jon decided to do, "just for the book." As he explained, "Let me show people some of the tricks I learned over the years."

By using the pounce wheel on the folded paper

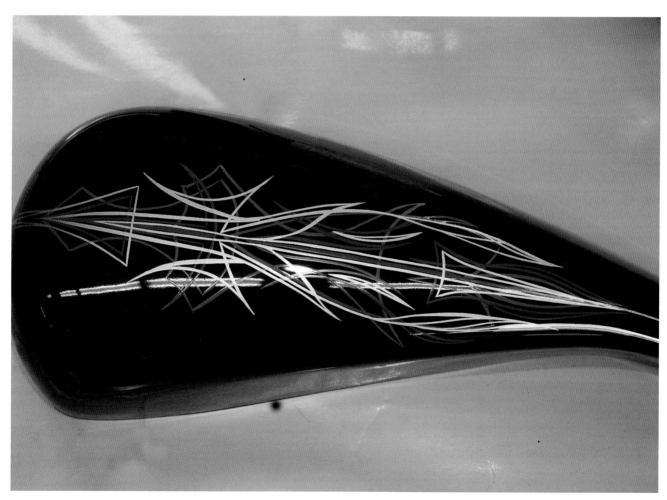

Here you can see our completed 3 color abstract pinstripe.

Captions by Jon Kosmoski

as shown, Jon is able to create a design with perfect side-to-side symmetry. Though Jon simply opened up the paper and used the whole design, you could just as easily cut the paper in half and use one piece on each side of the tank, or car.

Using the pounce wheel also allows a pinstriper to review the design on the panel – before laying down paint. If you don't like the design, just change it and try again. You could easily start with a sketch and run the pounce wheel over the sketch itself, without scanners or computers.

A pounce wheel, pad and colored chalk can be found at any good artists' supply store. In fact, you can make a pounce pad by putting the chalk into a rag, and then tying the rag into a bundle.

The design laid out with the help of the pounce wheel can be just the foundation for a much more complex pinstripe layout. Once you have the basic concept painted on the panel, you can add more stripes, in various colors.

The paint being used is obviously House of Kolor urethane striping enamel, described in more detail in the Q&A section that follows. Part of the beauty of this paint is the fact that it can be used with a hardener to create super tough pinstripes when the stripes are not going to be clearcoated. The same paint can be used (as seen here) with only a reducer, and then clearcoated later for protection.

This urethane paint can be wiped off without any trouble, as long as it's mixed without a catalyst (more later) on a surface that's been clearcoated. You can wipe off any mistakes with either the recommended reducer, or acetone. Jon puts a little on a rag then wipes carefully with one stroke, then comes back with another swipe, moving at ninety degrees to the first swipe. Of course this is hard to do when the design gets crowded.

As with other urethane paints, the catalyst is an isocyanate, i.e. a toxic and cancer causing material. So you have to follow the safety procedures used by body shops. This is not anything you want to inhale or allow to come into contact with your skin. You also have to be careful how you dispose of any left over catalyst. Remember though, you don't have to catalyze this product, you can simply stripe and clearcoat – with almost any type of clear.

Pounce wheels come in various sizes, including electronic models, the bigger of the two shown is a number 12.

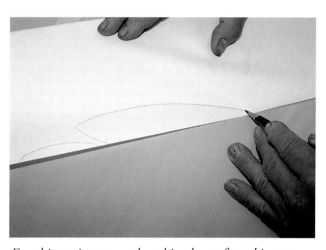

For this project we took a thin sheet of masking paper, folded it in half and then drew out our design on one half.

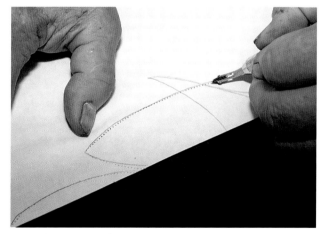

I put 30 pound felt (roofing material) under the paper, then I run the pounce wheel over the design. The felt helps the wheel cut nice, clean holes.

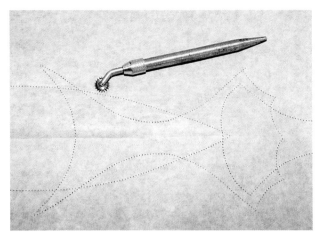

Once I open up the paper you can see our completed design.

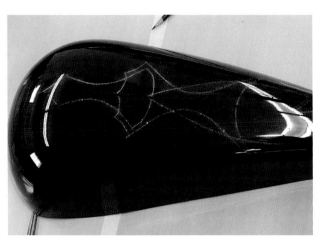

Here you can see how the design is transferred from the paper to the tank. The chalk is the same material used for a carpenter's "snap line."

This is the pounce pad we used to tap on the holes we punched (these are available at any good artists' supply house).

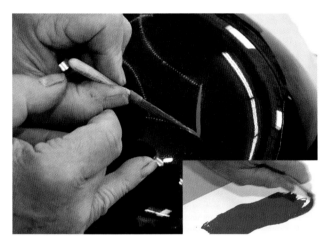

Now after loading the brush, making sure the consistency is correct and blowing off excess dust, I start striping using the pounce lines as a guide.

Just tap the pad lightly against the paper, this will read through the holes. If you don't like the position you can wipe the chalk off with a damp cloth, reposition the paper and do it again.

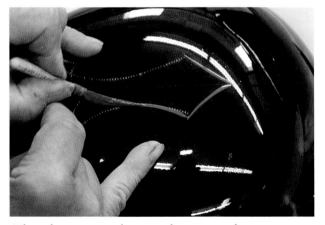

The advantage to doing it this way is the perspective - even from top to bottom, from one side of our initial design to the other. This gives a solid foundation you can build a good design upon.

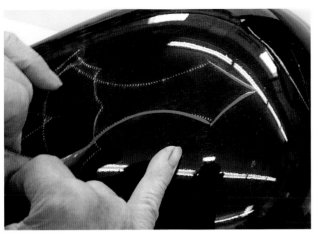

I like this shorter brush from Xcaliber, they're good for corners and tight work.

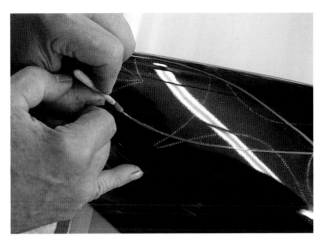

When turning, always rotate the brush between finger and thumb, or it will go out of control and get fat.

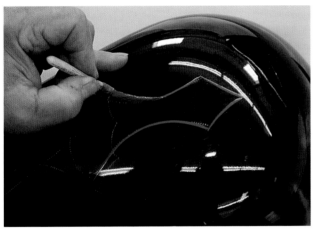

Pressure on the brush will determine the width of line, so it's important to keep the pressure even as I lay down these lines.

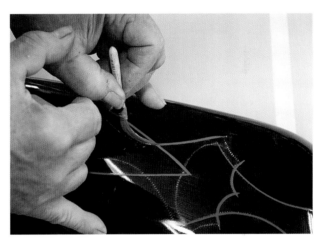

We are striping on clear urethane, normally we would have sanded it with 800 so it would be receptive to another coat of clear.

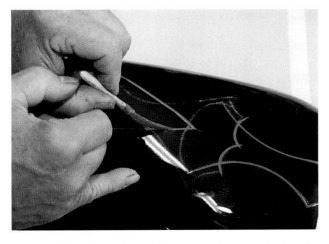

I go back to the palette often, to make sure the brush feels fairly loose and has a nice glide to it.

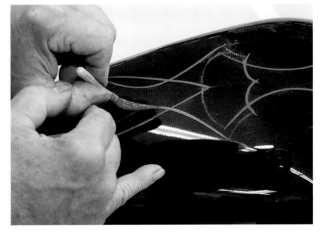

We are pre-planning here, leaving room for 2 more colors. We start with blue, then will go to red next, and with gold for the final color.

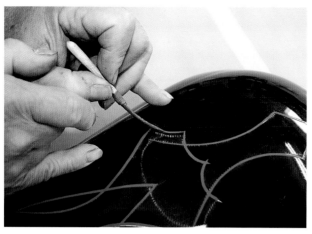

In situations like this you may have to do the initial line, then turn the brush around and come back at it from other direction to widen the line.

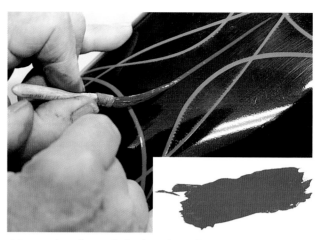

Now we've cleaned the brush and picked roman red as the second color.

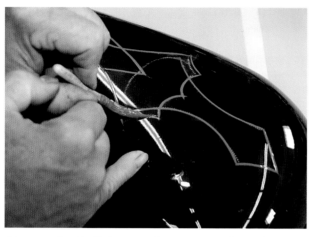

Having the chalk lines makes it easy to keep the perspective even. You can also pounce another panel first and use that to practice the design.

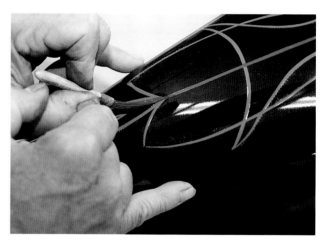

...now we freelance, working within the perspective we've set for ourselves. This is where the fun begins.

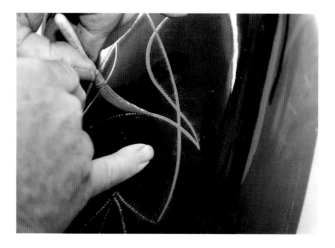

Here you notice I use 2 hands to make a nice smooth arc, I pivot off the little finger of my right hand.

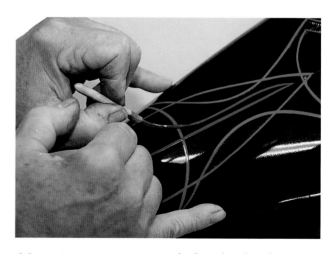

Many times we come in with the other hand to steady the brush hand.

Q&A Jon Kosmoski

Jon, you are primarily a painter, what made you take up pinstriping?

I always hired others to do the striping, pinstriping was a mystery to me. I would pick up a brush from time to time to outline a job or whatever. At that time pinstripers would not share secrets. So I learned from trial and error. I often threw the brush across the room, but I didn't give up. The key to good pinstriping is practice.

What made you develop your own line of pinstriping paints, and why make them urethanes and not something more traditional and oil based?

Dissatisfaction with existing products. I thought, what could you do if price was no object, and used the best pigments, and solvents and resins? I designed the system as a urethane-based system because there was a lacquer based system already, and I was playing with urethanes for regular paint. I wanted something that could be cleared.

What are some of the advantages of using urethane as pinstriping paint?

Long life. It can be cleared easily, even with lacquer, it's OK (as long as no catalyst). It's all things to all people. It is fast drying but stays wet enough on the brush to stripe and brush well. Best of both worlds, quick dry but not too quick

By the time you've cleaned the brushes and the other materials it's usually dry and you can start to clear. But you still need to follow our guidelines and not push on too many clearcoats, too quick.

When you clearcoat over pinstripes, what procedure do you follow and which clear do you like?

I prefer our UC 35, it's pure urethane, with K100 catalyst. I like to use RU 310 reducer, it's the fastest one we have. In Texas you might have to mix fast reducer with some medium reducer. But in a seventy to eighty degree shop the RU 310 usually works great. Remember, you don't need to clear the whole car, just clear the stripes. Then the next day you can come back in and clear the whole car, and then you won't feel the bump where the pinstripe is.

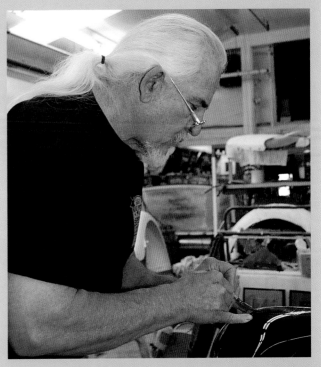

Are urethane stripes easier to "bury" under clear than the oil based stripes?

Yes, the urethanes have about a third the bump compared to a typical oil based pinstripe paint. This obviously makes it easier to clear and have a smooth surface.

You have your own way of storing the brushes, can you describe that and explain why it's a good idea?

When you work with oil it's a good thing to store the brushes in oil. But with urethane I clean them in acetone, it's a good solvent. I clean them three or four times, right up to the hilt. Then I blow them off, blowing carefully in the direction of the bristles. This leaves them fluffed and looking like new brushes. And I store them dry.

Any final words of wisdom?

Remember to keep the height of the stripe consistent, roll the brush through the tight corners. Go back to the palette often. Don't let your brush get too tight. Sometimes when you're having trouble, you might think it's you, but often it's the brush that has lost its feel. Pick up another brush and try again. And practice. practice, practice.

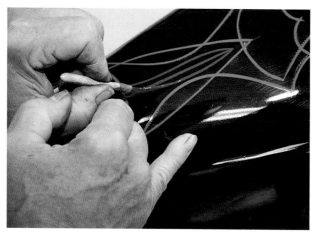

Now you can see we have something very interesting happening here. Look for balance of color throughout the job.

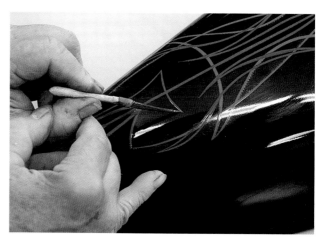

Again, 2 hands to steady the brush, look where you want to go ahead of time, use existing lines as perspective guide to keep it as even as you can.

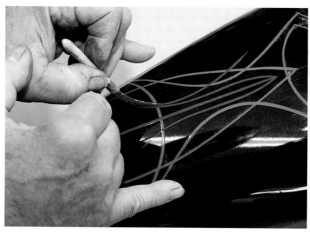

Remember to continually go back to the palette, add enough reducer so the brush isn't too tight.

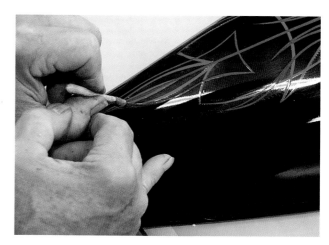

Now we have a little space between the front and back art. I can pull all this together with the third color.

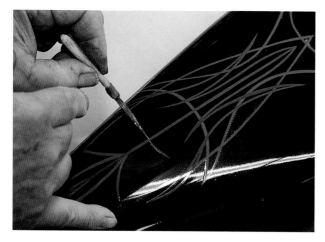

Here I'm hooking together additional details, real details which make it look more difficult that it really is.

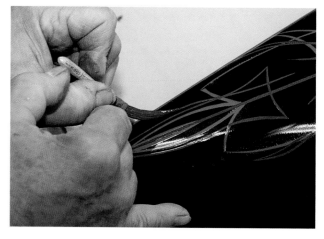

I'm running this line from front to rear, and will duplicate the line with another on the other side of the tank.

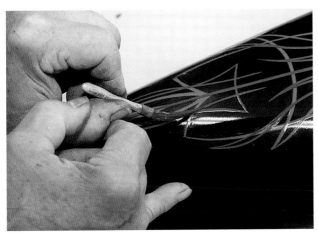

Here's the matching line. Stripers who use catalyst add it to the reducer, then use that reducer throughout the whole process.

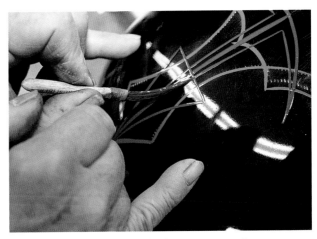

...adding more lines with the Roman Red.

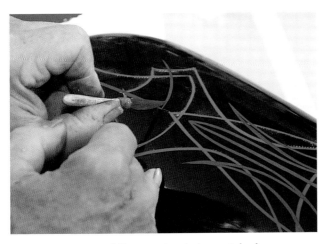

I just continue adding to the design with the roman red.

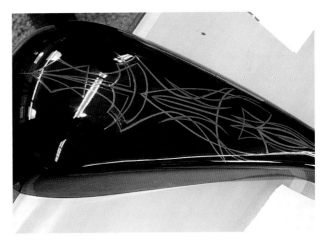

Progress so far, I think we need just one more color.

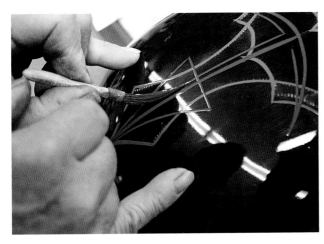

Again, I'm working within the existing design...

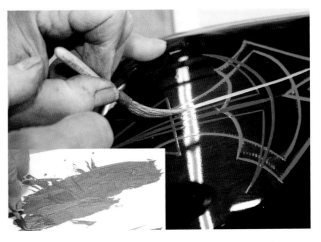

Notice how bold the gold line is against the other colors, this will pull everything together. Gold is often useful and works with a lot of other colors.

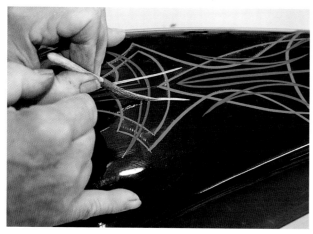

Now, using my own imagination and the existing stripes, I start filling in the voids.

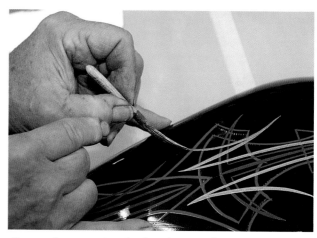

Remember to twist the brush on tight turns. Once you master this, you will have fun as this paint is very easy to work with.

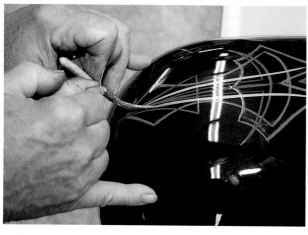

Adding some detail to the front. You might not like what you do, mistakes can be wiped off if you're working on a catalyzed clearcoat.

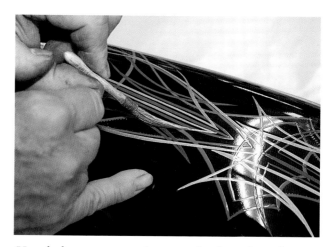

You do have to remember to go back to the palette often, use our U 00 reducer to keep the viscosity consistent.

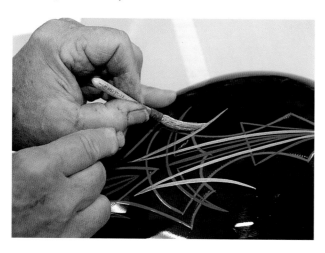

Or, mistakes can be turned into part of the design by duplicating the effect on the other side,

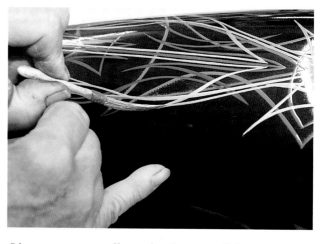

It's very easy to pull another line parallel to an existing line. Don't be afraid to T off, or branch out. It's your design.

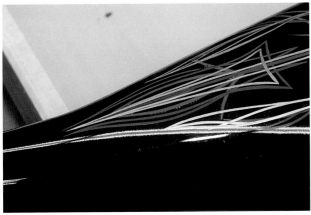

For much of the gold I just parallel the existing work already done in blue and red.

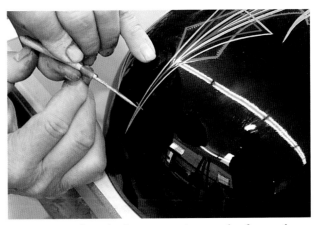

Here we make a little cross section at the front, these little details are done with a light lift on the brush to get a nice fine line. I start from one side then turn around and pull the line from the other side.

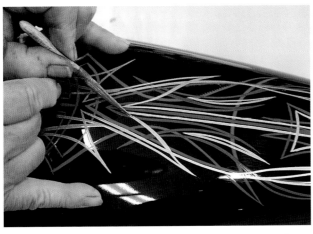

You can see now we look pretty artsy and busy, what we see more of now are narrow designs, with some of that old school look from the 50s and 60s.

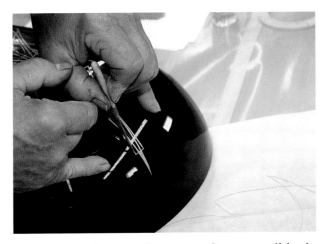

Now that we have made our cross line, we pull back and merge this part of the design into the rest of the gold.

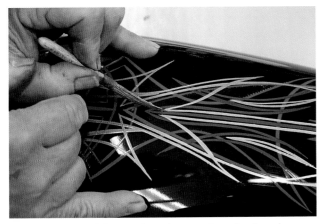

Now we are adding points by turning the brush around. You can go back and forth until you're totally happy.

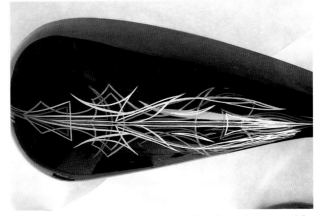

Our final art work, fairly complex though we could add more. If you don't like the design wipe it off and begin again. You have to satisfy the customer, but you also have to satisfy yourself.

Chapter Ten

Tex McDorman

Stripeology 101

This chapter will show some of the work of the Stripe Masta "Tex" McDorman of Sanger, Texas. He's not just a great striper, painter and airbrusher, but also a great artist. He originally opened his first shop in Chesapeake, Virginia with his wife Melissa. This was a combination paint shop and sign shop. She handled the signs and he did the art work. Eventually they added a vinyl machine to speed up production and to bring in more commercial work.

This is the finished 50's Ford dash striped for Alan. It's a piece of hot rod art that's going to hang in the Auto Ranch in Denton, Texas.

Text and photos by Gene Slater. Captions by Tex McDorman.

They sold their business, "Tex's Sign Shop" in 2002, and moved back home to Texas. "TEXEFX" was re-established in Texas in 2003. The shop is set up mainly to do custom work on motorcycles and NASCAR helmets. "A lot of our clients are well known and don't care where they need to go to get work done, so being in the country is not a problem," explains Tex.

Before the striping on the dash could start, Tex sprayed the dash with House Of Kolor black. Next came inner-coat clear with heavy silverflake. He then topcoated with a mixture of kandy lime, gold and organic green, followed by urethane clearcoats. At this point it was sanded with the Quick Cut Sanding system, then buffed out.

The paint is easily mixed in the cup, this also allows you to palette the brush to remove excess paint. You don't want to start your stripe with a drip forming on the end of the brush.

We used House Of Kolor products on this job. Squirt bottle is for easy dispensing, the Dixie cups for mixing. Make sure you get the paper cups, no wax coating. (RU 311 was not used with the striping paint.)

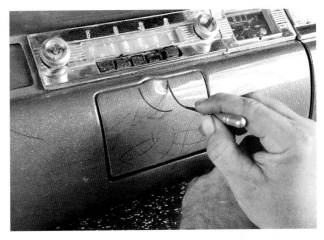

This design starts in the front center of the dash which happens to be the ashtray. This will be a focal point where all the other stripes originate.

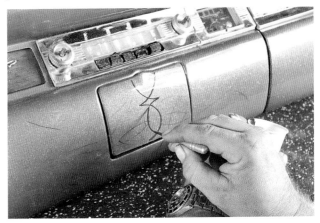

Once you have the center, work your design around it. Start on the left side (if you are right handed) and then duplicate it on the right side. Sometimes crossing center is a must.

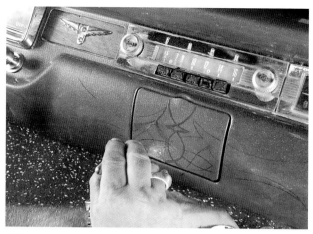

The center piece is done for now (but not finished). It's the "trunk" that's going to support all the weight of designs coming from it.

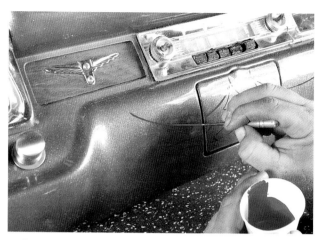

After I've done both lines, I may need to straighten out one or add to the thickness, so the two of them match.

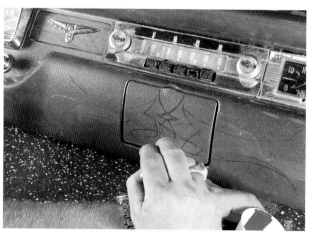

Don't be afraid to come back to the center to add more detail. It can come in handy later.

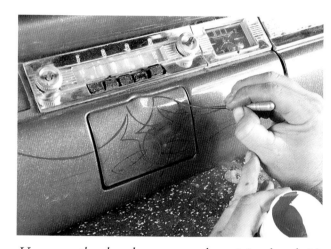

Use your other hand to support the striping hand. It's also easier holding the paint cup. Note how my hand is so multifunctional!

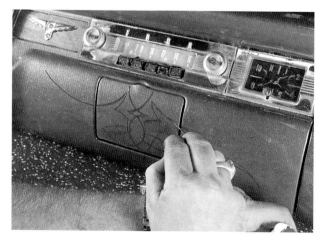

I add a limb, coming from the center out to the left, then duplicate it on the right.

A nicely balanced trunk with a couple of support limbs. We are just getting started.

Take note how I'm holding the brush, like I would hold a pencil. This will allow me to turn the brush using my fingers and not my arm.

This is a side stroke, so I don't need my left hand for support. I'm using the pinky finger as balance. It's the only part of my hand that touches the dash.

This is an up stroke from center out, see how rolling the brush has moved the brush to the middle finger, the index finger is more on top for balance.

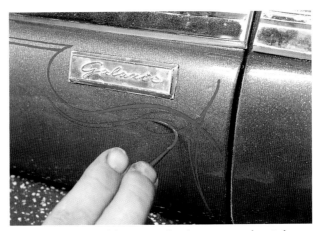

I'm using the emblem as a focal point on the right side. Doing curved and radius lines is going to require rolling the brush and moving my arm at the same time.

We are bringing the right side of the dash into the center trunk. Both sides of the dash are different, but will have some of the same limbs connecting them so they look similar.

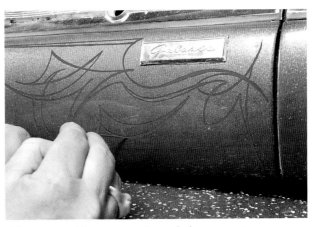

This was a big space and needed some serious attention. Everything originates from the detail around the emblem. Be creative and not constrained!

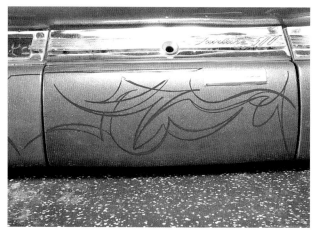

This is just "free handin'" and not a design that's center balanced like on the ash tray, but it is still connected to the trunk.

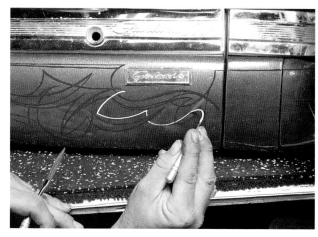

More than likely the red is still wet or at least tacky, so be careful not to get your hands in wet paint. Sometimes this takes strategic placement of fingers.

I'm now adding the second color. This needs to be brighter than the first color, but still complement the primary color.

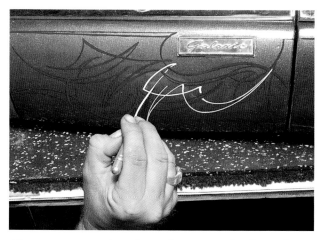

Try not to re-stroke a line if it crosses the first color while it's still tacky. If it's dry there's no problem.

The white also starts on the center trunk and works out. The design you start with will dictate where you add the second color.

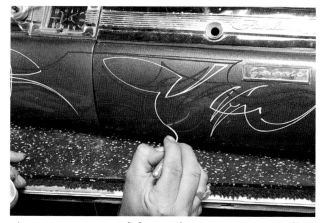

Accenting your trunk lines takes imagination. Follow one line for a distance, then alter or even reverse direction. Run some lines over the main design, and some under - the design will appear to be interlocked.

Q&A: Tex

Tex, how did you end up as a striper and custom painter?

I was influenced early on by my grandmother who was a well-known artist. Oil painting on canvas was her specialty. She made her living as an artist.

My cousin Chuck was the one who inspired me to do motorcycle work. He never owned a bike but had a room full of motorcycle posters and a lot of Easy Rider magazines. I really don't think he knows how much he inspired me or gave me that push. He was cool and popular. I thought maybe that was the right way.

I imitated the things I saw in books. Being 13 years old and trying to figure out how to draw and stripe was challenging. Especially since Brownwood, Texas is not a hot bed for aspiring hot rod and chopper art. You have to learn to look all around for art inspiration.

My mom has done artsy, fartsy things all her life, she enjoyed it and made it seem fun. My dad is also a great pencil artist, but never does it. He's always been too busy working for a living. His relaxing time never seemed to involve drawing. He is where I get my drive for organization, and my endless dedication to getting jobs finished on time no matter what it takes. I don't think he's ever been late.

Do you have formal training?

No I don't, but often times I wish I did. I think that maybe ideas or colors would come easier. All of my learning has been trial and error. Being a painter, striper and such requires a lot of practice, and being a chemist of sorts. I sucked at chemistry in school!

What do you use for paint?

If the job is getting clearcoated I use House of Kolor striping enamels. They dry fairly fast and are easily cleared. For striping on existing paint that's already been cleared I use One-Shot. It flows great and holds up well, and also stays shiny.

What brushes do you use?

Lazer Lines Artist Brushes. They are made in Pasadena, Texas. They have so many different brushes, they have one for anything you could ever possibly want to do.

Is pinstriping all you do?

No, we take the project from raw metal to buffing. Our son, Critter, helps do all of the prep and basecoat painting. I will do the airbrush, spray, lay graphics and stripe. Then he will typically sand and buff. He's 19, but has a lot of experience.

In all of our spraying and airbrushing we use Sata spray equipment. It works great for what we do. When sanding for prep, and for final buffing we use Quick Cut Sanders. They use a self-contained water sanding system, and trust me, it makes the jobs go a lot faster and turn out smooth.

Any final comments?

I take pride in the admiration of my art. Art is an interpretation of an individual's personality.

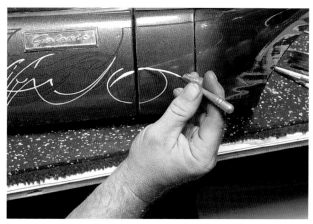

Rolling the brush through my fingers makes this circle fairly simple. If you need to, lay a circle or oval template down and lightly trace the pattern with a Stabilo pencil.

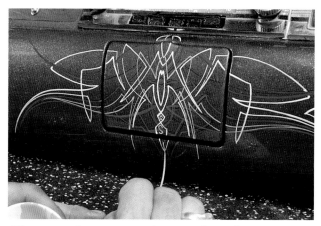

This is my favorite step, because through the first two steps certain images or specific designs emerge. The third color can be used to accentuate that image or design.

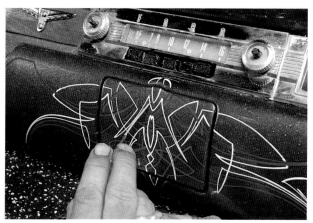

The third color is not as bright as the second color. These are like leaves on a branch, they are sporadic yet intentional.

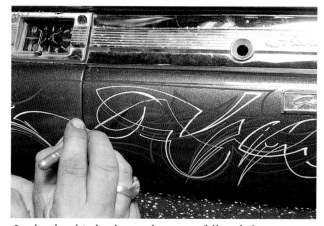

I take the third color and start to follow below or above the first. When I get close to the second color I follow it. Go with the flow. Don't just throw a line out there unless you know where it's going.

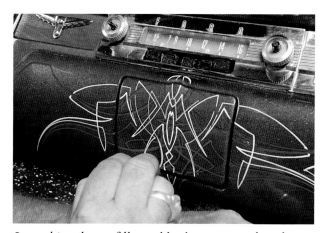

I use this color to fill any blank areas, maybe where a little more detail is needed. This color only needs to accent the other two colors and not be too busy. Too much of it will overpower the other colors.

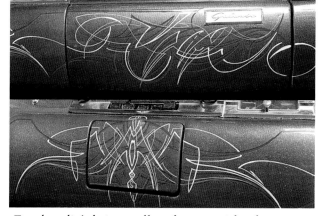

Free handin' designs roll and move with whatever shapes you have. Centered designs use sides that are nearly identical. They could be considered mirror images of one another.

This design is all free handin'. I'm just going to pick an area to start and see where the shapes of the object I'm painting take me.

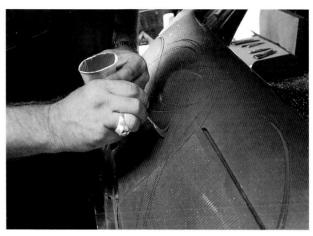

Most of this striping starts on the outside edges and works to the center. I'm not going for a certain focal point here. I want your eyes to move all around.

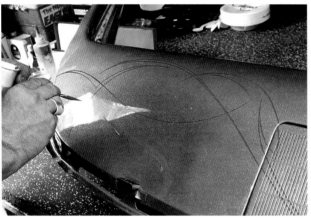

Because this dash is big and I want it all to be striped, I'm not going conservative here. This takes a long haired brush that carries a lot of paint for a long stroke.

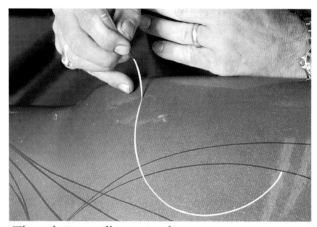

These designs will meet in the center one way or another, but not carry the same detail. This one is going across the speaker - not always a good idea. The holes often make the brush jump.

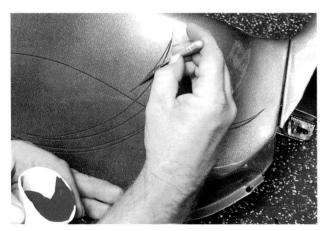

You can use the same long haired brush for doing the more detailed work. This is different than the red scarlet brush I used on the front of the dash. It's designed for small detailed striping and scroll work.

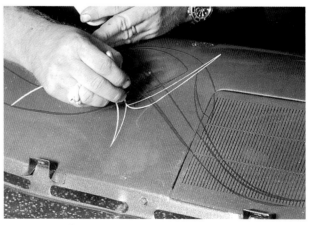

Try a spot first to see if it's going to work. If not, go around the grill. If you can go across the grill the design will definitely flow better and give you limitless designs.

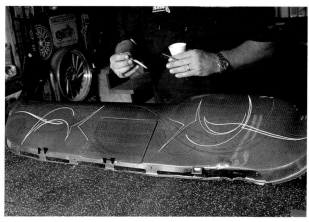

Step back for a minute and look at where your design is going. It takes a while to get used to visualizing the next lines you need to add in order to make all the pieces fit.

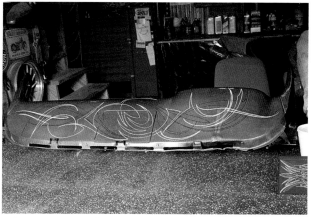

It's coming together and needs the third and final color. I look it over to see if there are too many empty spots. In the end, I think this color in its simplicity will really connect the two sides.

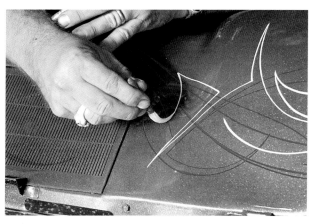

When I get to a crack or body line, I lift up slightly on the brush to relieve some pressure, but continue on in one fluid motion. I can come back and re-stroke the line to fatten or straighten it up if needed.

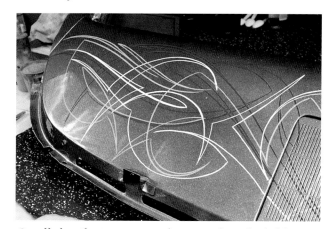

Small details, in certain places, make it look like you knew it was going to be green in that area when you started in there with red.

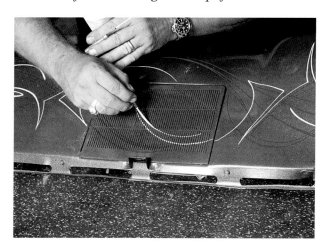

This is just a little design in the center to join the two sides. Not too detailed. Remember, no focal points here.

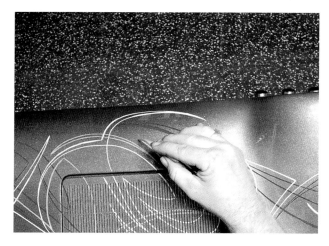

Watch that hand! A mistake here is BAD! It's almost impossible to wipe it off without getting into the other two colors.

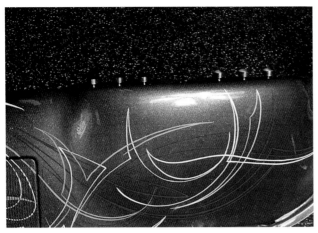

If you make a mistake, which I doubt after all this instruction (ha), don't panic! Stop, take a breath and look to see if you can make it into something.

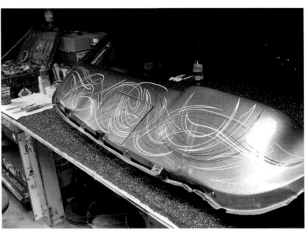

When you are beginning, you practice to make it all work. When you're a "Masta", you work to make it perfection.

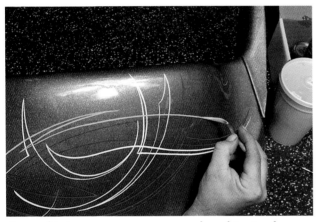

I put this in on purpose, you see the white in the center of the "U" shape? The curve down and then back up does not flow with the rest of the design. But I made it work, since removing it is not possible.

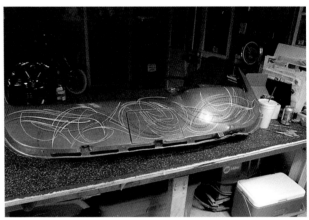

The finished product ready to be admired, and amaze small children as well as the curious. Not knowing all the while it was done in these easy steps.

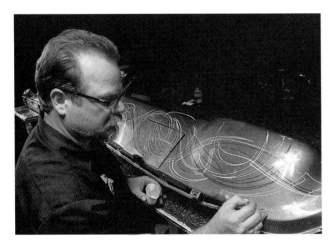

Don't let the mistakes define you. Work to make it come together, and relax.

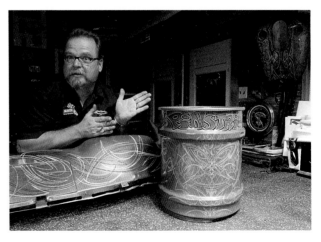

The key is practice, practice, practice. Practice on anything and everything. Cans, doors, electrical panel boxes, drill presses, whatever.

Chapter Eleven

Brian Truesdell

Essential Pinstripes

Brian Truesdell started out working in his uncle's sign shop. Pinstriping was something he did on the side, "just because I was always into cars." Today he runs a small shop in West St. Paul, Minnesota with his brother, Brad and son, Cory. They do everything from truck lettering to pinstriping on hot rods.

"The nice thing about having my son here," explains Brian, "is that it gives me a little more time for painting. He's been to school

Pinstripes started out not so much as art, but simply as a means of cleaning up an edge where to colors meet, or where a flame or graphic design intersects the main color. They've come a long way from that simple job, as seen here where two-color stripes outline and enhance a flame job on a late-model Bagger. Captions by Brian Truesdell

for computers and he's a pretty good designer, so he can do a lot of the computer generated signs and lettering."

Brian attends a number of panel-jams or pinheads meetings each year, where he's developed a reputation for precision. "When I walked into one of the events recently a guy who'd been there the year before said, 'here comes Mr. Perfect.' Which I guess is a compliment. Some of the guys leave the corners of a pinstripe job sloppy or overlapping, and the lines aren't the same thickness or positioned the same from side to side."

"Sometimes it takes me longer to do something because I just can't leave it until everything is just right."

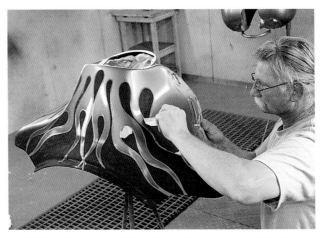

1. This job starts with a flame job done by Mallard Teal in St. Paul.

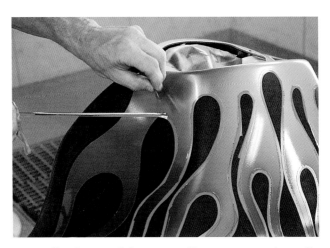

2. Mallard is careful not to pull any paint as he pulls the tape, note the razor blade in his left hand.

3. Close up shows that even after cleaning up the edges with an X-axto knife, there is still the need for a stripe to clean up the edge.

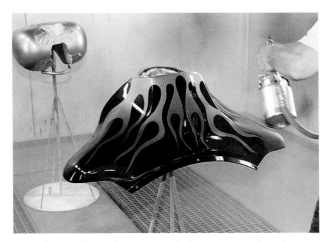

4. After pulling the tape and cleaning up the edges, Mallard applies a clearcoat, allows it to dry, and scuffs the surface before the striping begins.

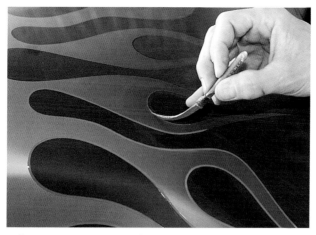

The sequence I use to do the striping depends to some extent on the position I can get the parts into...

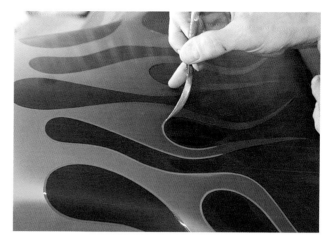

When you do curves like this you have to stand the brush up on end.

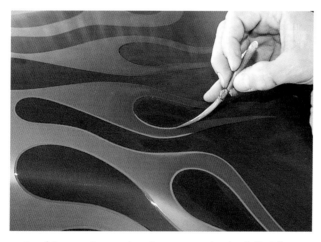

...in this case I start in the center, do the left side...

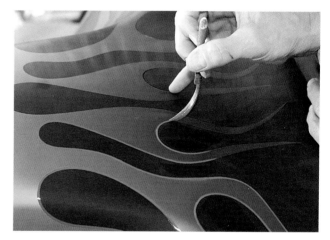

And yes, I do roll it as I go through the tightest part of the curve.

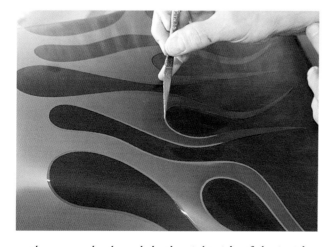

...then come back and do the right side of the inside curve.

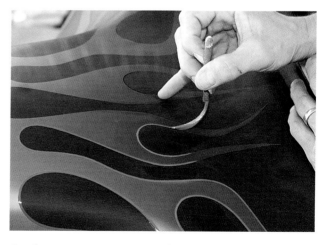

In this instance I use my other hand to support my wrist and keep the brush up high.

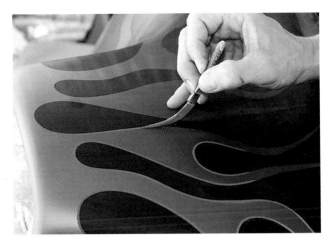

2. ...and continue...

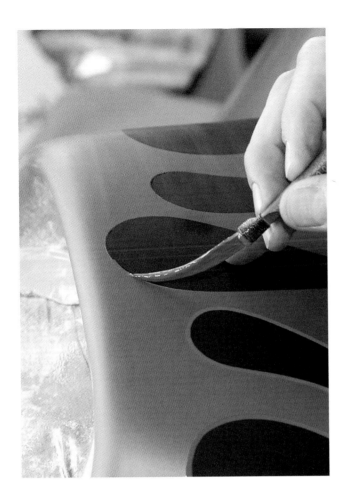

1. Again, I start on the lower, or left side...

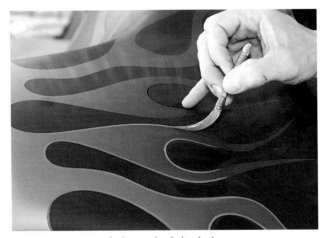

3. ...back toward the end of the lick.

4. I don't go all the way back though because the tips will be a different color.

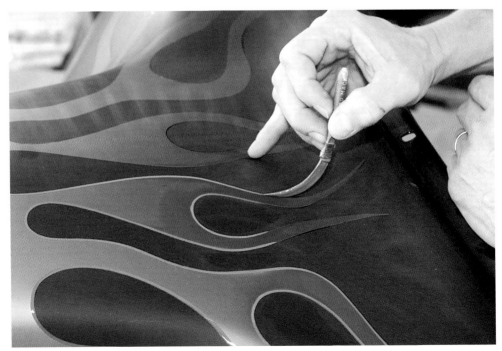

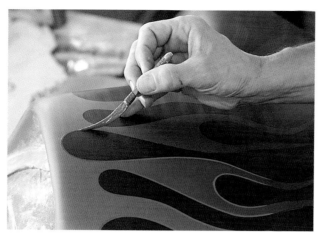

2. Notice the difference in the angle of the brush as I go from the tight curve...

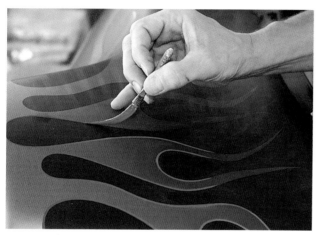

3. ...to the more gently arcing part of the flame layout.

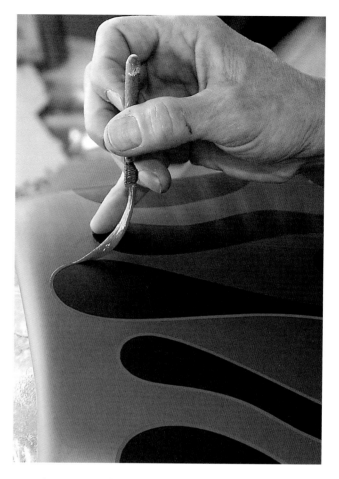

1. When I come back to complete the arc, I overlap the line by about an inch.

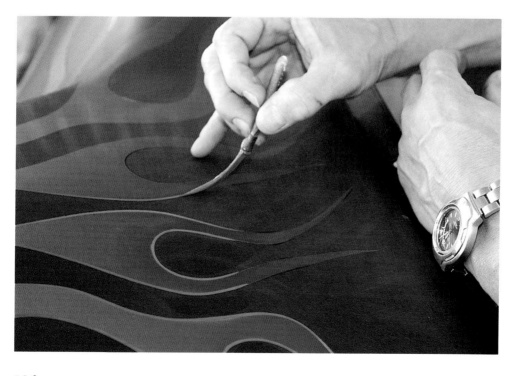

4. The color is medium orange, the brush is my trusty Mack.

Q&A Brian Truesdell

Brian, how did you become a pinstripe and lettering artist?

I was always into cars, as a kid I saw some pinstriping on a friend's car and thought, 'I could do that.' I decided to give it a try so I bought a couple of brushes. At the time I was working at my uncle's sign painting shop and going to school for sign painting two nights a week. Pretty soon I was working at the sign shop during the day and doing pinstriping at night. When my Uncle sold the company I never had to go and look for a job, because I already had a business. That was in 1978. And I've been striping ever since.

When I first started it was Dave Eckel and Cliff Anderson, they were the best known of the local pinstripe guys. I learned by looking at the work they did. There was no help in those days, no one would tell anyone anything. I practiced on a steel Coleman cooler. I would stripe it, wipe it off and stripe it again.

Where do you get your ideas?

Now there are so many in my brain I just go there. The old skool stuff is hot now. At this point I can pretty much duplicate whatever anybody wants.

What do you like for brushes?

Mack - period. The original green wrap number one. I use that brush for thick and thin lines, I save one that's older for the thin lines.

How about paint?

I always use One-Shot. If the stripes are going to be cleared, I use hardener. I buy generic high gloss acrylic enamel hardener and mix that with the One-Shot.

Where do you get your ideas for color and color combinations?

By seeing other people's work, and then working out combinations that you know work well together. Colors and pinstripe styles are both subject to trends, it's a very trendy deal. For example, no one used pastels until the 1990s. Now they're gone and we're back to primary colors.

Any advice for the person starting out or who wants to get better?

First, never cut up the brush, learn to stripe with the brush that Mack makes. You might cut off a couple of loose bristles that stick out, but that's it. I never cut the belly of the brush. If you need to do really fine lines, buy a 00 or 0000 size brush.

Second, learn how to stripe with one hand, not hand over hand. I started out working on trucks so I had to learn to pull three foot lines. I do use hand over hand, but very seldom. Otherwise it's just the brush and the little finger for support. Those are the two things I would tell someone who's starting out.

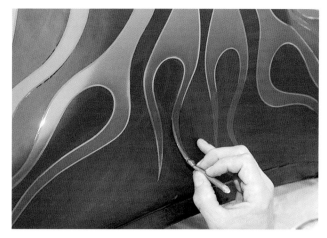

1. Here I'm finishing up the fairing...

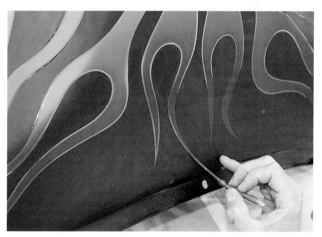

2. ...I'm blending the red color (vermillion) used at the tips, with the medium orange used on the rest.

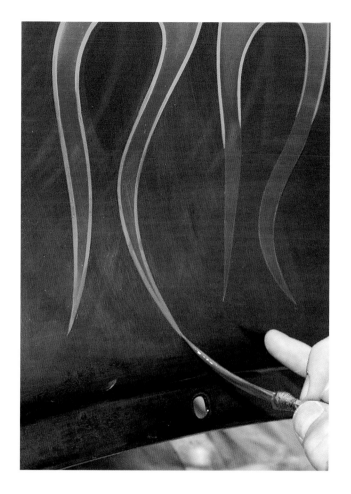

4. ...the effect is subtle but adds another dimension to the stripes.

3. To blend the two colors, I just overlap the two stripes by about an inch where they meet...

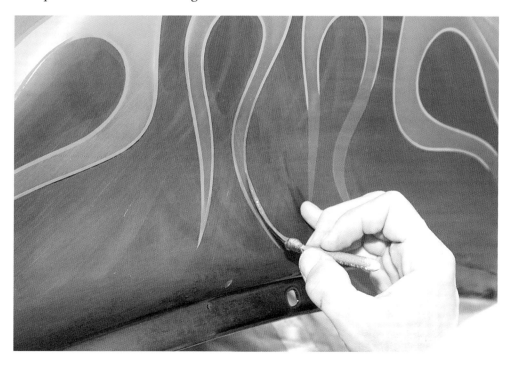

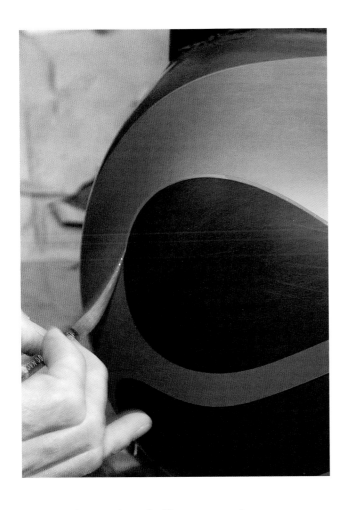

4. ...until I get about half way around.

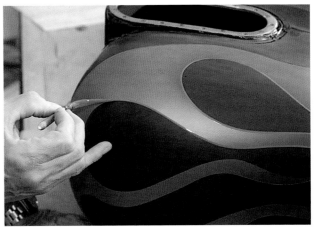

1. As I said earlier, how I approach the curve depends on the object...

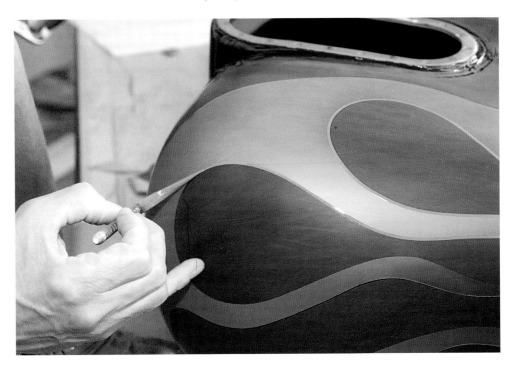

2. ...and its position. Here I started back at the end of the flame lick...

3. ...then just continue around the bowl of the flame...

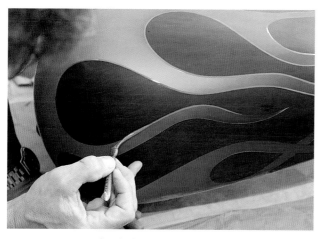

1. Now I come back from the end of the lower lick...

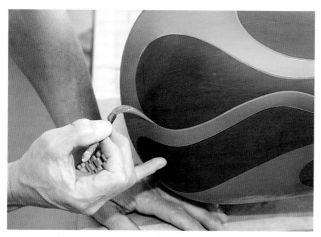

2. ...and go part way up the big curve.

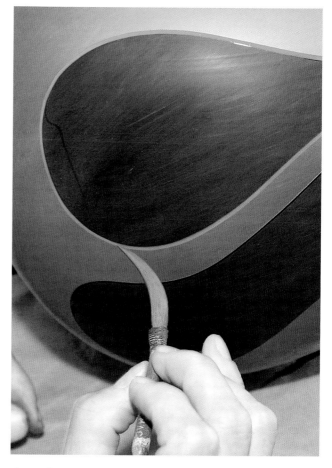

4. And continue the stripe all the way around, overlapping at both the beginning and the end of this final segment.

3. Then I stop and start again where I left off on page 139.

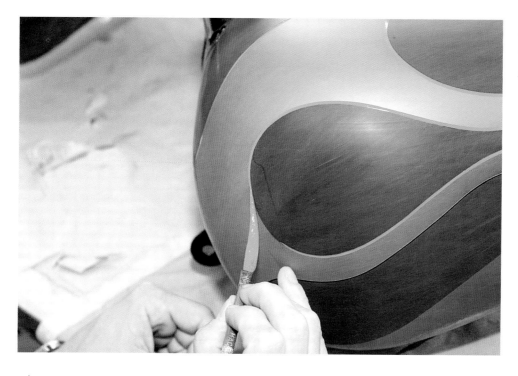

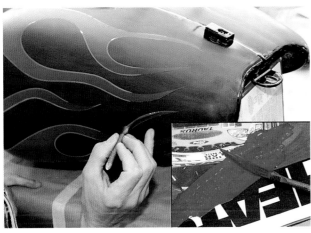

Here I'm doing the tips in vermillion. I like to palette the paint with turpentine as it seems to have more bite that way.

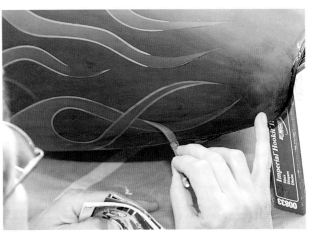

...but in cases like this it's up to me. So I just pick one to be on top and one to be under, and make sure I do it the same on both sides.

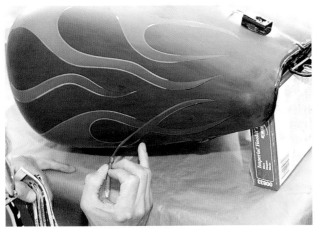

When licks overlap, I have to figure out which is the over and which is the under.

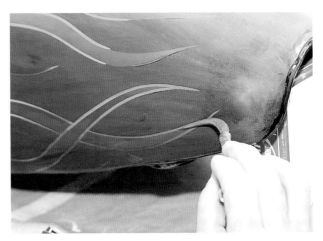

When I get to the end I've run out of places to put my pinky...

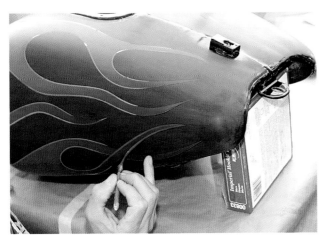

It can depend on the painter. If one lick is shaded then that's the under...

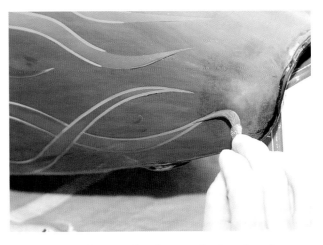

...so you just have to finish it up freehand without any support.

HOW TO BUILD A CHEAP CHOPPER

Choppers don't have to cost $30,000.00. In fact, a chopper built at home can be had for as little as $5,000.00. Watch the construction of 4 inexpensive choppers with complete start-to-finish photo sequences. Least expensive are metric choppers, based on a 1970s vintage Japanese four-cylinder drivetrain installed in an hardtail frame. Next up are three bikes built using Buell/Sportster drivetrains. The fact is, a complete used Buell or Sportster is an inexpensive motorcycle – and comes with wheels and tires, transmission, brakes and all the rest. Just add a hardtail frame and accessories to suit. Most expensive is bike number 4. This big-twin chopper uses a RevTech drivetrain set in a Rolling Thunder frame. Written by Tim Remus. Shot in the shops of Brian Klock, Motorcycle Works, Redneck Engineering and Dave Perewitz this book uses numerous photos to Illustrate the construction of these 4 bikes.

Eleven Chapters 144 Pages $24.95 Over 400 photos-100% color

HOW TO BUILD A SOFTAIL

Got a Softail? Got a hankering to separate yours from all the other Softails parked outside the bar? Search no farther than this new book, How To Hop-Up and Customize Your Harley-Davidson Softail, from well-known author Timothy Remus. Whether your goal is to personalize that two-wheeled ride or give it more than 60 horsepower, the ideas and answers you need are right here.

Learn how to install a 95 inch kit with over 100 horsepower, add a 250 rear tire, lower the bike, and add extended fuel tanks. Make yours faster, sexier and more personal with this all-color book from Timothy Remus and Wolfgang Publications.
How to: Lower Your Bike
 Design a Custom Softail
 Install New Sheet Metal
 Build a Budget 95 Inch Motor

Nine Chapters 144 Pages $24.95 Over 300 photos-100% color

HOP-UP & CUSTOMIZE YOUR H-D BAGGER

Baggers don't have to be slow, and they don't have to look like every other Dresser in the parking lot. Take your Bagger from slow to show with a few more cubic inches, a little paint and some well placed accessories. Whether you're looking for additional power or more visual pizazz, the answers and ideas you need are contained in this new book from Tim Remus.

Follow the project bike from start to finish, including a complete dyno test and remapping of the fuel injections. Includes two 95 inch engine make overs.
How to:
• Pick the best accessories for the best value
• Install a lowering kit
• Do custom paint on a budget
• Create a unique design for your bike

Eight Chapters 144 Pages $24.95 Over 400 full-color photos

ADVANCED AIRBRUSH ART

Like a video done with still photography, this new book is made up entirely of photo sequences that illustrate each small step in the creation of an airbrushed masterpiece. Watch as well-known masters like Vince Goodeve, Chris Cruz, Steve Wizard and Nick Pastura start with a sketch and end with a NASCAR helmet or motorcycle tank covered with graphics, murals, pinups or all of the above.

Interviews explain each artist's preference for paint and equipment, and secrets learned over decades of painting. Projects include a chrome eagle surrounded by reality flames, a series of murals, and a variety of graphic designs.

This is a great book for anyone who takes their airbrushing seriously and wants to learn more.

Ten Chapters 144 Pages $24.95 Over 400 photos, 100% color

Sources

Andrew Mack Brush Co.
225 East Chicago St.
PO Box 157
Jonesville, Michigan 49250
(517) 849.9272
Mackbrush.com

BT Design
Brian Truesdell
1062 Dodd Rd
W. St. Paul, MN 55118
(651) 451.4842
btdesign4u.com

East Coast Artie
1200 Glenns Bay Rd #5
Surfside Beach, SC 29575
(843) 215.3600
eastcoastartie.com

Hanson, Keith
233 Canton
Stoughton, MA 02072
(781) 344.9166

House of Kolor
210 Crosby St.
Picayune, MS 39466
(601) 798.4229
houseofkolor.com

Kafka Inc.
10443 N. Cave Creek Rd.
Phoenix, AZ 85020
(602) 943.8119

Kite, Dan
19W 142 18th Place
Lombard, IL 60148
(630) 660.9916

Kosmoski, Jon
House of Kolor
(800) 844.4130 voice mail box

Krazy Kolors
Lenni Schwartz
5413 Helena Rd N
Oakdale, MN 55128
(651) 773.9015

Laser Lines Artists Brushes
6522 Inverness Way
Pasadena, TX 77505
(281) 991.9712
laserlines.com

Pastura, Nick
6020 W 130th St.
Brook Park, OH 44142
(216) 433.1205

Peters, Mark Pinstriping
Paintings ~ Graphics
208 Montford Ave.
Ashville, NC 28801
(828) 253.4445

Pradke, Robert
232 General Lyon Rd
Eastford, CT 06242
(860) 974.3292

Sid Moses
Pinstriping Brushes
(800) 628.2194
(310) 475.1111
moseart.com

Sign Gold Corporation
53 Smith Road
Middletown, NY 10941
(845) 692.6565
Signgold.com

TEX EFX
Motorsport Graphics
6200 Crow Wright Rd.
Sanger, TX 76266
(940) 482.9969
TEXEFX.com
tex@texefx.com

The Wizard
Steve Chaszeyka
11497.5 Youngstown-
Pittsburgh Rd.
New Middletown, OH 44442
(330) 542.4444